Creative Illustration & Beyond

Walter Foster

www.walterfoster.com
Walter Foster Publishing
3 Wrigley, Suite A
Irvine, CA 92618

Publisher: Rebecca J. Razo
Art Director: Shelley Baugh
Senior Editor: Stephanie Meissner
Associate Editor: Jennifer Gaudet
Assistant Editor: Janessa Osle
Production Designers: Debbie Aiken, Amanda Tannen
Production Manager: Nicole Szawlowski
Production Coordinator: Lawrence Marquez
Production Assistant: Jessi Mitchelar

Printed in China.
1 3 5 7 9 10 8 6 4 2
18388

Table of Contents

Introduction

An illustration is a picture that communicates, and an illustrator is a person who tells a story with pictures. There is much debate over whether illustration is an art form unto itself. I say, "Yes!"

Illustration has grown to have a wide audience and can take many forms—from digital and graphic to publishing and personal art pieces and prints. Illustrations have the power to artistically express an idea, evoke emotion, share an experience, or simply embellish a page in a beautiful fashion. It's all about communication, and it's personal! The images you illustrate are a direct reflection of your unique artistic style; like a signature, they can become a trademark to characterize your work. With the exciting prompts, exercises, and step-by-step projects inside this book, you'll learn to move beyond the basic act of recording lines and shapes. You'll discover myriad fun, creative ways to weave a story into your drawings, doodles, and paintings with carefully chosen details, facial expressions, and composition.

You'll find tips and techniques for creating narratives; expressive art projects; and recognizable, relatable characters that can be put to use for anything from personalized gifts and home décor to commercial work. In the end, your images will engage your audience, inspire imagination, and encourage a little story to sprout simply in their viewing!

How to Use This Book

The information contained in this book is designed to help you elevate your drawings to illustrated art and learn to tell your own collection of stories through visual pieces! After learning about some of the specific tools and materials you'll want to have readily available, you'll learn some fun and inspiring ways to get your illustrative juices flowing. You'll then be invited to replicate a variety of borders, embellishments, and other elements directly in the pages of this interactive workbook.

Browse through the book from cover to cover the first time you pick it up. Familiarize yourself with the content. Then use it as a resource for any of the following purposes:

-A reference and inspiration when artist's block strikes;
-A catalyst for learning to develop your own illustration style;
-A guide to multiple illustration styles when you're looking to add a new form to your repertoire;
-Examples of fun, easy art projects you can give as personalized gifts; and
-Much, much more!

Above all, this book is designed to help you communicate better through your art and find endless creative uses for your drawings. Lots of open practice pages throughout offer space for practicing the techniques described so you can put your newfound skills to use!

Happy illustrating!

Basic Tools & Materials

These are my essential tools for the styles of illustration you'll find in this book.

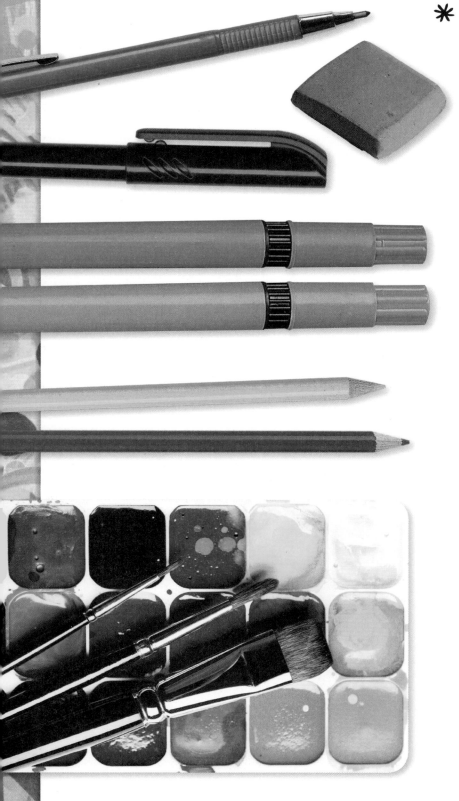

Mechanical Pencils I rarely use traditional graphite drawing pencils. The always-sharp, thin lead of a mechanical pencil is ideal for drawing fine details, and it suits my style better.

Kneaded Eraser You can mold these pliable, gray erasers into pointed shapes to erase small areas. They don't shred your paper or leave eraser dust. This is the only kind of eraser I use.

Archival Ink Pens I always have multiple nib sizes of these pens on hand. I use super fine (.01mm), fine (.05mm), and brush tips most often. Super fine nibs are great for faces and detailed doodles and patterns. A fine tip is my choice for everyday drawing. A brush tip is excellent when you need varying or heavier line thickness.

Watercolor Pencils & Colored Pencils Watercolor pencils are great for a controlled and tidy application of color that can be "smoothed out" with a little water. Standard colored pencils are excellent for adding color with a bit of "tooth" and texture.

Watercolor Pan Set Pan sets with multiple shades are great. They are the quickest way to add color and a layered look to a drawing. Watercolor textures and transparency are unmatched and really suit my aesthetic. They are affordable, easily portable, and great for all ages!

Paintbrushes I am a paintbrush junkie! My favorite paintbrushes for watercolor are round, natural bristle brushes, such as sables. For acrylics, I like synthetic and natural bristle filbert brushes with long handles in ½-inch to 1½-inch widths.

Digital Camera I could not function without my camera. Macro photos of textures and in-progress works are some of my favorites to share online. I also take lots of source photos for poses, textures, and composition. I take high-resolution photos of finished artwork for posting online, using in self-promo pieces and making print reproductions.

Acrylic Paints Arylics are not as quick and portable as watercolors. However, I love the rich, vibrant colors they produce. Acrylics are fast-drying and offer excellent coverage to add bold pops of color to your illustrations.

Paper The projects in this book require a variety of surfaces, including inkjet printer paper; tracing paper; watercolor paper; and heavy cardstock, such as scrapbooking paper, notecards, and assorted colored paper.

Craft Knife & Metal Straight Edge Every trimmed invitation, print, letter, and stencil requires these handy tools. I buy replacement blades in bulk.

Lightbox A lightbox is a compact box with a transparent top and light inside. You can tape your rough drawings the surface to turn it on, and the light will illuminate the dark lines in your drawing so you can accurately trace it onto a new sheet of paper. For illustration, a large lightbox with a glass top is endlessly useful. I use mine to trace and clean up my drawings, transfer text and images to art surfaces, and as a cutting surface for my razor knife. It is the primary workstation in my studio.

Computer/Scanner/Printer/Graphics Tablet Computers and other hardware are essential for creating digital files, tweaking colors, cleaning up stray lines in sketches, editing source photos, printing copies, storyboarding, and creating digital layouts. Many of my ideas are roughed out digitally with my graphics tablet and stylus before they are realized on paper or canvas—Photoshop® and Illustrator® software are like an extension of my arm!

Graphite Transfer Paper This paper is graphite-coated, and acts as carbon paper to transfer-trace a design onto another surface. It is greaseless, which makes it clean to work with!

Liquid Frisket Liquid frisket is a masking material that is used to protect specific areas from color. You can use frisket on a white surface or over color that is already dry. When you're done painting, simply rub off the dried frisket with your fingers.

Beating Artist's Block

Need some help getting the creative juices flowing? Inspiration can be found in some of the unlikeliest places. The ideas on the next few pages will help unleash the artist in you.

Brainstorming 101

Below are some questions to ponder whenever artist's block strikes. You'll be surprised just how easy it is to fuel your creativity! Review the questions below; then write your answers in the spaces provided on the opposite page.

What's nearby?

Look around. What do you see? Even everyday objects (a coffee cup, a banana, a set of colored pencils) can inspire illustrations. What's in your closet? Fashion can inspire patterns and designs. What's outside? Nature can inspire botanical sketches, textures, and bold color palettes.

What do you need?

Is there a special occasion or event coming up? How about making a piece of art as a gift? Is there a bare wall you've been meaning to fill? Now's your chance to add a personal touch. Have a friend in need of uplifting words? How about an encouraging hand-lettered phrase?

What sparks your creativity?

Pretty photographs, picture postcards, fabric swatches, paint chips. What are the things that inspire you?

- Keep a folder of inspiring images on your computer.
- Keep a magazine bin with dog-eared pages for reference.
- Keep a binder with sleeves to hold precious tidbits, mementos, ticket stubs, and art.
- Utilize social media sites such as Pinterest™ to create virtual mood boards.

What's your go-to artistic happy place?

Whether you prefer doodling, casual sketching, hand lettering, or graphic illustration, pick up your art tool of choice, and just go there! When you are making art in a form that you love, the creativity will follow.

What's nearby?

What do you need?

What sparks your creativity?

What's your go-to artistic
happy place?

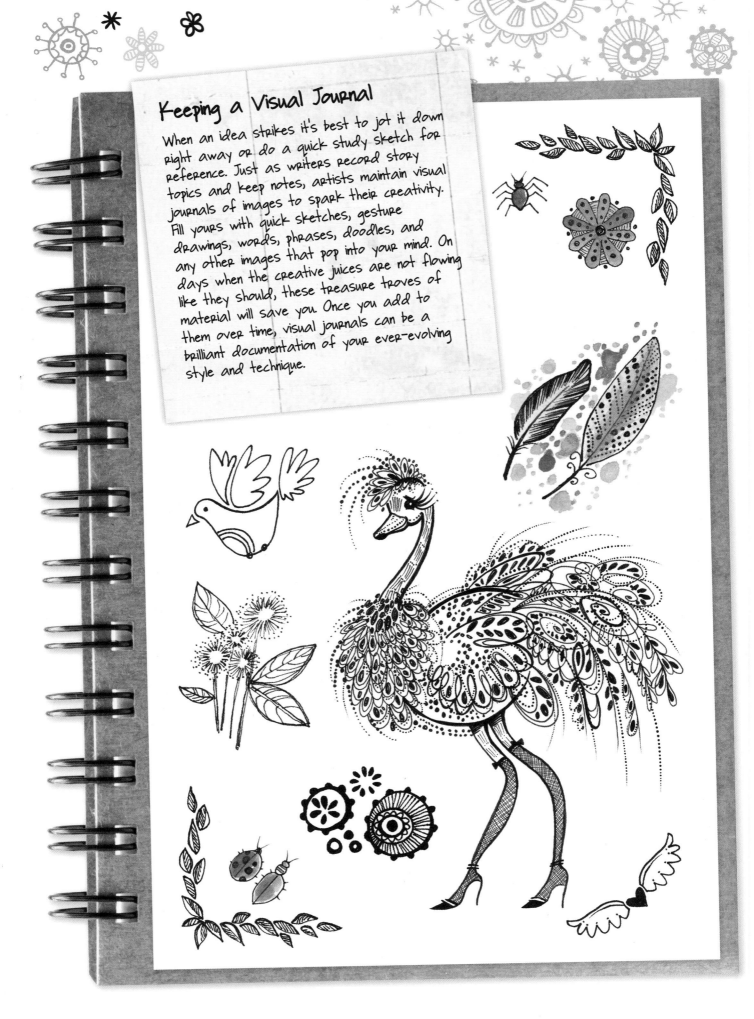

Keeping a Visual Journal

When an idea strikes it's best to jot it down right away or do a quick study sketch for reference. Just as writers record story topics and keep notes, artists maintain visual journals of images to spark their creativity. Fill yours with quick sketches, gesture drawings, words, phrases, doodles, and any other images that pop into your mind. On days when the creative juices are not flowing like they should, these treasure troves of material will save you. Once you add to them over time, visual journals can be a brilliant documentation of your ever-evolving style and technique.

Illustration Tips & Cheats

Below are some of my favorite tips for developing an efficient and effective creative process.

- **Use a lightbox** to transfer sketches, duplicate an object or character, align text, or practice your craft.
- **Create a new texture.** Throw down puddles of watercolor, splashes of acrylic, or scribbles of pencil. Then scan it, tweak the colors using Photoshop®, and use the resulting image as a background in your final art pieces.
- When creating multiple scenes with a single character, **maintain continuity** from scene to scene by rendering them at the same time, side by side. Use gesture drawings to start, which are easier to tweak and correct.

- **Use the Internet** for visual sourcing. For example, if you're drawing a cartoon cat, pull up a screen of cat photos for reference.
- Draw for no other reason than to **enjoy yourself.** Your best, most unique work will come from this.

- **Experiment** using a variety of art supplies in multiple ways. Toothy paper and a dull pencil can make even the roughest sketch look more artistic.
- **Tie themed illustrations together** with color. A tight color palette instantly unifies individual drawings.
- **Make use of digital sketching** and editing to map out a dynamic layout on screen before you put pen to paper.

- **Draw from your memory and imagination.** The ideas that emerge when you are not tied to a reference photo are often remarkable.
- **Layer like colors for depth.** A red-orange over a yellow-orange for shading is nice. A cool blue over pale tones creates shadow and dimension. Transparent lemon yellow can add a kiss of sunlight to a character's hair and shoulders.
- **Make art out of what is nearby** and on hand. Paint on shoes and fabric. Sketch on wood. Use fabric dyes on paper or glitter glue for texture. Use your imagination!

- **Make scans** of your line art before adding color. Your effort will pay off double. Line art can be made into stamps, clip art, coloring pages, screen print designs, and more.
- **Take high-, low-, and eye-level photos** of all sorts of things for more dynamic source images.
- **Doodle** over your kids' abstract paintings for instant kitschy charm and a meaningful collaborative artwork!

Let The Fun Begin!

The next few pages feature a variety of creative borders, banners, embellishments, and illustrations. Use the open areas to practice these stylized drawings—or to create some of your own!

Practice Here!

13

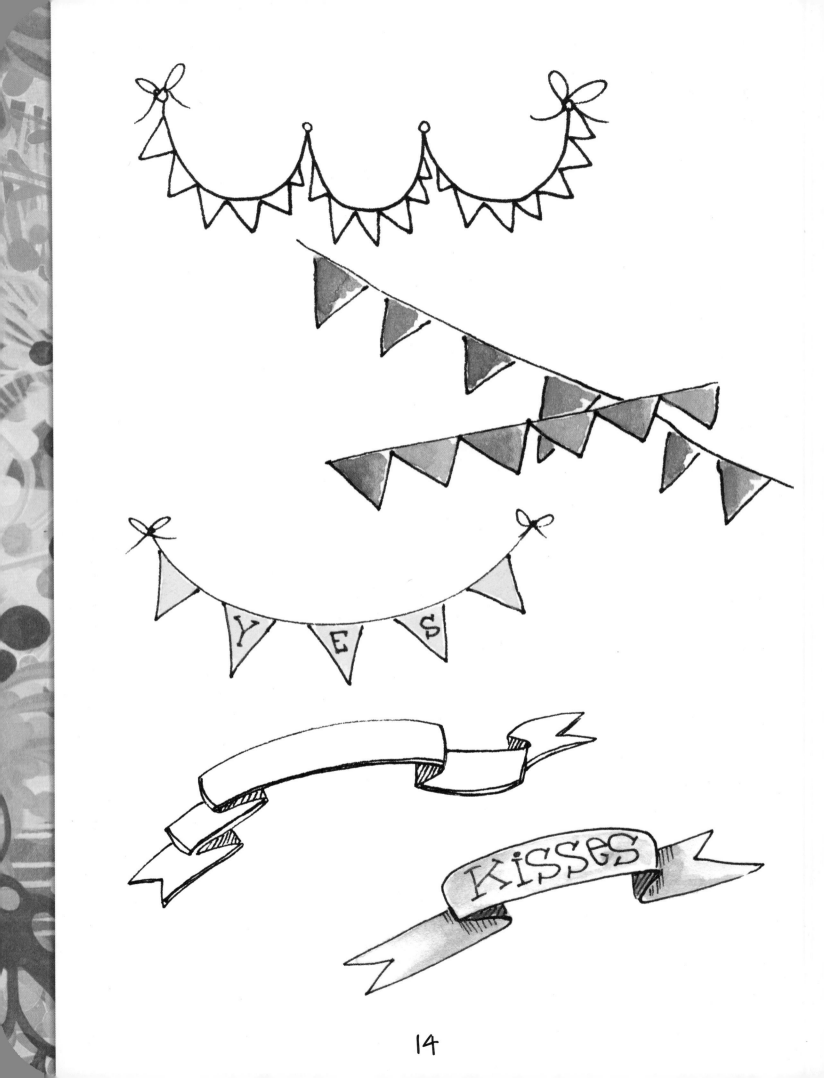

YES

KISSES

Practice Here!

17

Practice Here!

19

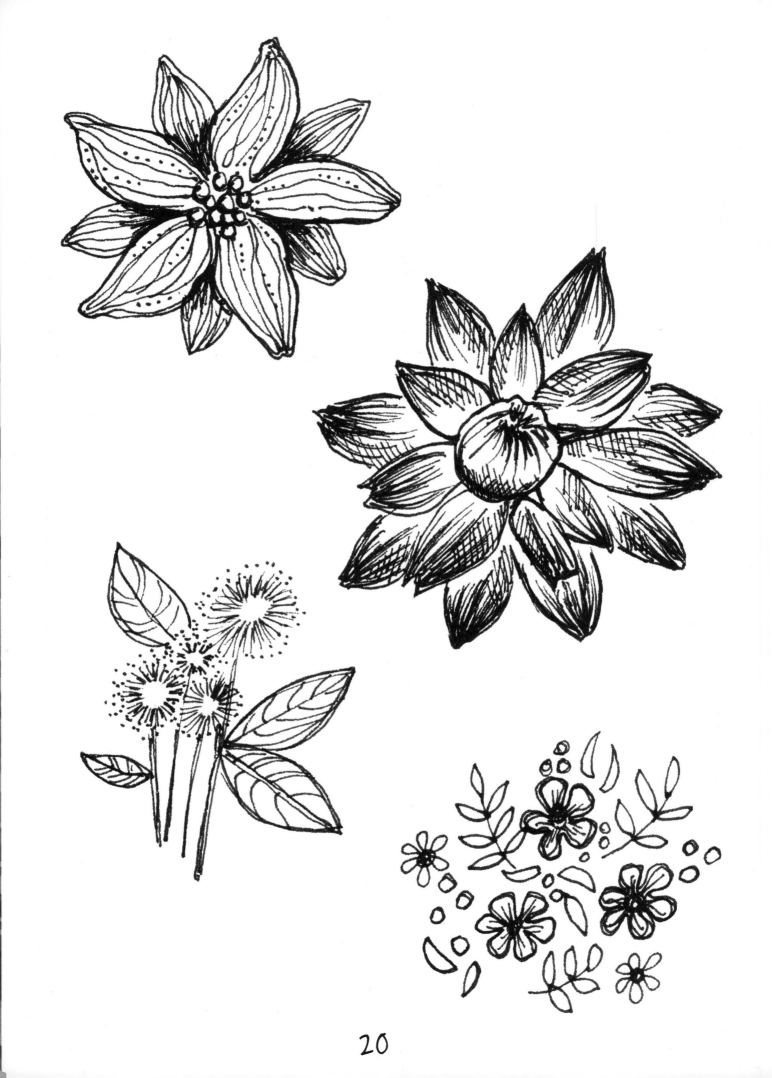

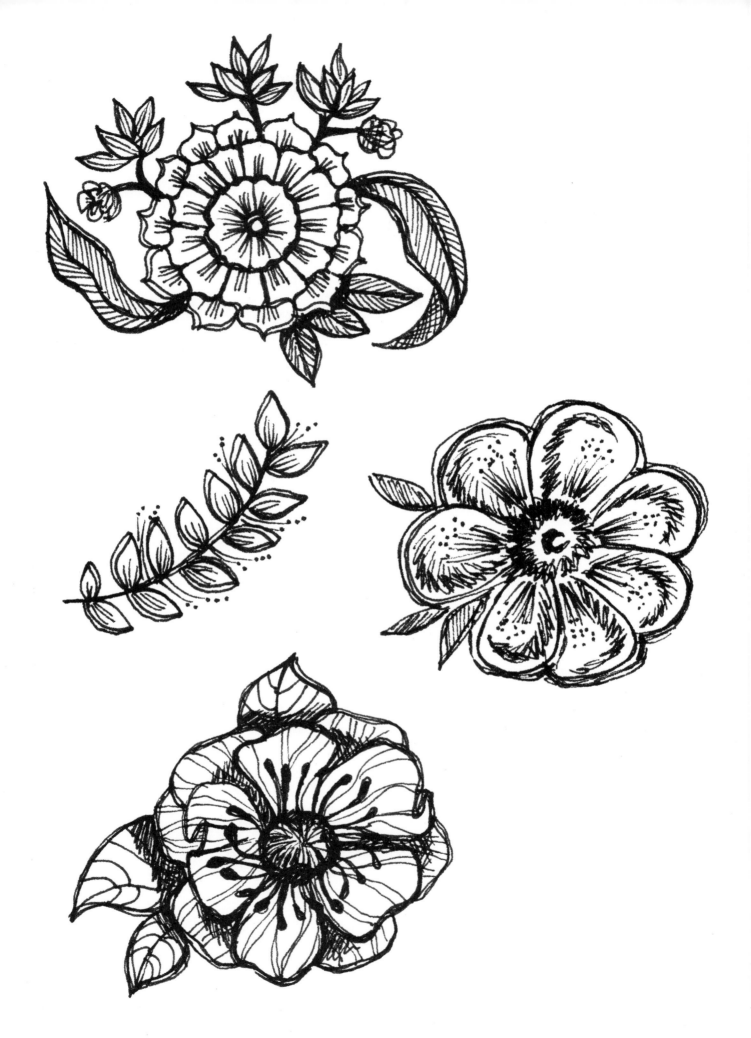

Practice Here!

Express Yourself

Your handwriting says a lot about who you are. Are your strokes loopy and swoopy, controlled and careful, or large and bold? Word art can be a window into your artistic style and perspective, and it often starts with your own signature.

Practice different handwriting styles, using your signature as your guide. Start by signing your name like you usually do. Look carefully at your signature; then challenge yourself to give it an opposite "personality." For example, if your signature is sweet and girly, make it bold and masculine. If it is heavy-handed and angular, make it wispy and curvy.

Original

Opposite

Now sign your name as though you were:
1) a movie star
2) a teenager
3) a kindergartener
4) a librarian

Movie star

Teenager

Kindergartener

Librarian

Original

Opposite

Movie star

Teenager

Kindergartener

Librarian

Playing With Words

A beautifully painted phrase or illustrated word can have a powerful, inspiring impact. Elements such as shapes and silhouettes, scale and proportion, and texture and dimension add interest to any word picture. Try flourishes and twirls for a fancy look, or bring your own personality to any snapshot, page, document, or chart with a custom font. Using the illustrations below as inspiration, practice creating your own word illustrations.

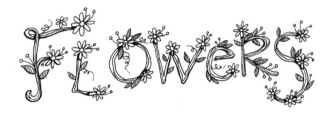

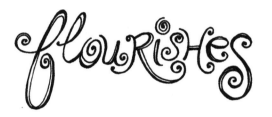

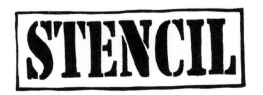

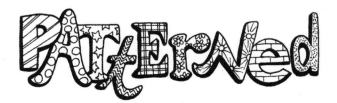

Practice Here!

TIP
Displaying wedding vows in elegant calligraphy or funny quotes in playful lettering creates a cherished memento.

REVERSE

SKINNY

SERIF

OUTLINE

METALLIC

Embroidered

Fuzzy

dotted

Doodly

CHiLdish

ETCHED

BEVELED

BLOCK

Calligraphy

Practice Here!

Shape Up

Many graphics and logos contain letters that are drawn to form the shape of an object or an idea. There is freedom to drawing these types of words because there are no rules—the letters can simply morph into whatever you want them to be. On the opposite page, follow the steps below to try your hand at drawing an object-shaped word.

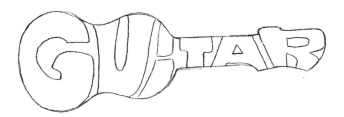

Step 1 Draw a faint, simple outline of your object.

Step 2 Draw the middle letter(s) of the word in the center of the outline to establish spacing.

Step 3 Add the rest of the letters.

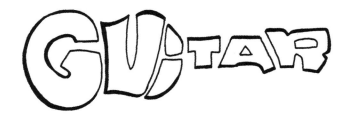

Step 4 Erase your pencil outline and ink the letters.

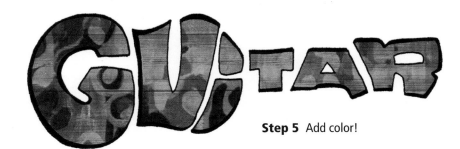

Step 5 Add color!

More examples:

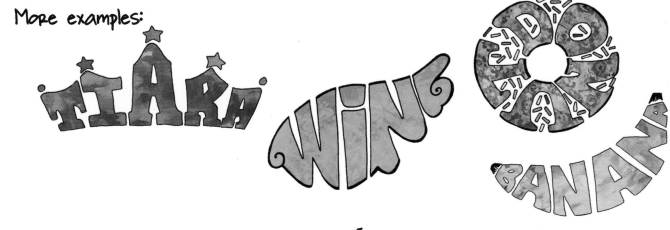

Hand-lettered Family Tree

Even text-heavy diagrams can be artistic! This project will teach you how to build a whimsical family tree using three types of lettering.

Tools & Materials

- Watercolor paper
- Watercolor paints and brushes
- Liquid frisket (masking fluid)
- Coarse salt
- Pencils
- Black archival ink pen
- Scissors or craft knife
- Lightbox (not shown)
- Double-stick tape or glue

Step 1 On regular drawing paper make a sketch of your tree, using any style you like. Maintain ample white space between the branches, and keep an open area in the shape of a heart or an oval in the base of the trunk.

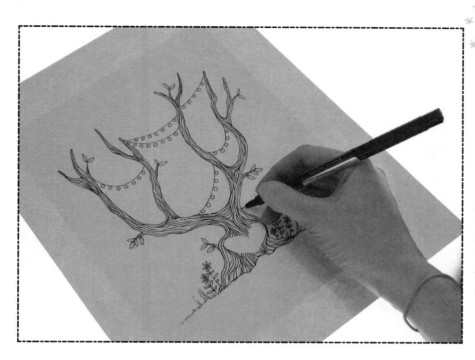

Step 2 With the aid of a lightbox, use ink or pencil to transfer your drawing to watercolor paper. (See "Lightbox" on page 7.) Leave 3" of white space at the top and bottom of the paper and 2" on the sides.

Step 3 Lightly sketch the family name in the space below the tree. Use simple lettering, as this will yield the best results with the frisket. Paint a layer of frisket into your outline with a fine brush and let dry. (See "Liquid Frisket" on page 7.)

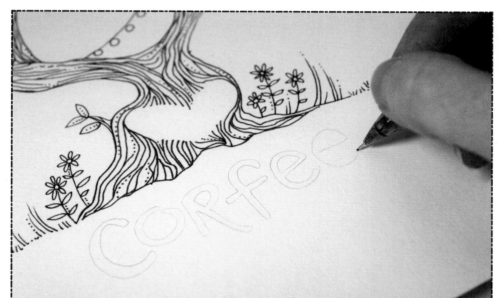

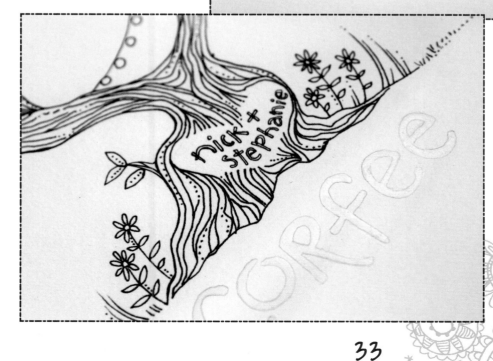

Step 4 Draw the primary name(s) inside the open area on the tree trunk. Illustrate in a style that looks like letters carved into the tree.

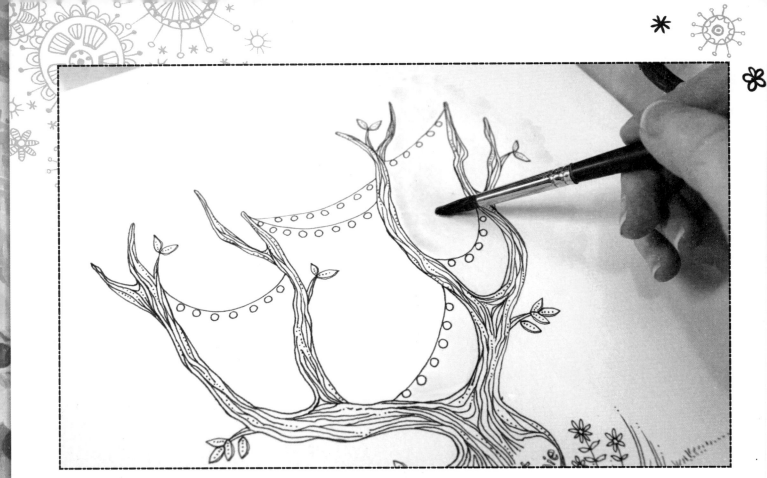

Step 5 Paint over the name you treated with the frisket, which masks the letters and protects them from the paint. Using your brush, wet the area between the branches, as well as the grassy area beneath the tree. Use a touch of paint to tint the water and to help you see the areas you are painting.

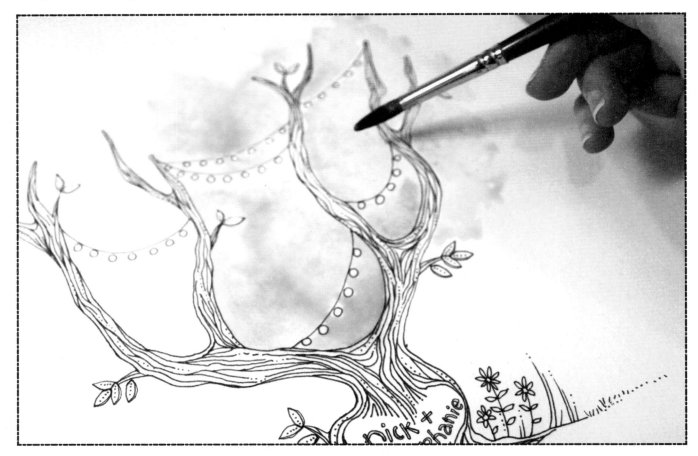

Step 6 Now dab in various greens and yellows to the wet areas and allow them to blend. Add a sprinkling of coarse salt to the wet paint and let it set for a dappled, textural effect.

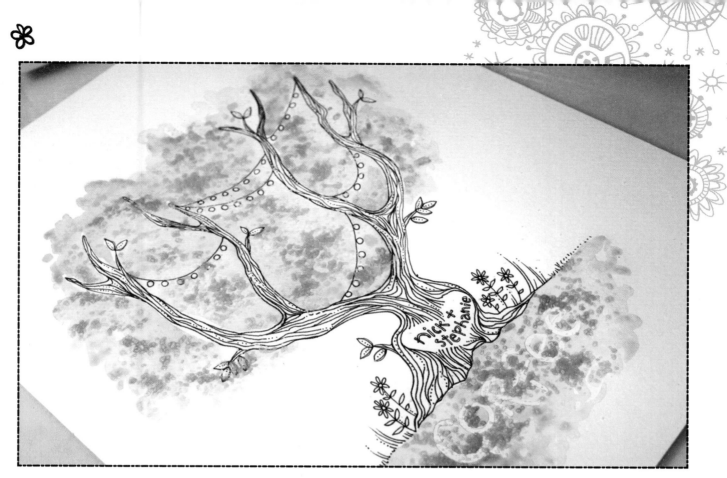

Step 7 Add a few extra drips of watercolor paint over some of the salt clusters. Allow the paint to dry.

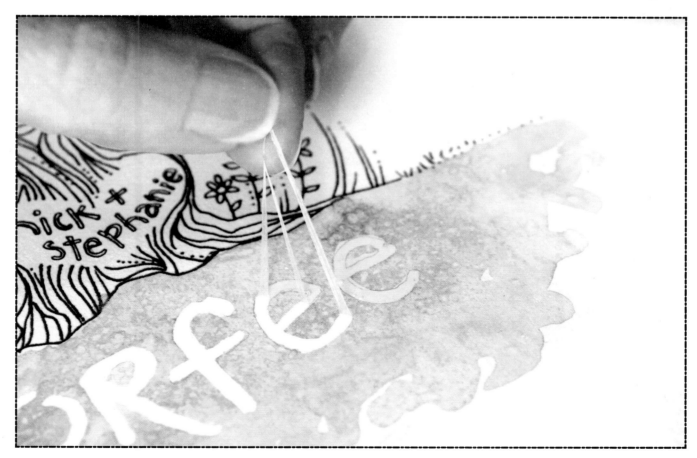

Step 8 When the paint is dry, brush the salt away gently. Then gently remove the rubbery frisket, using a kneaded eraser or your fingertips. Some areas will pull up in one piece.

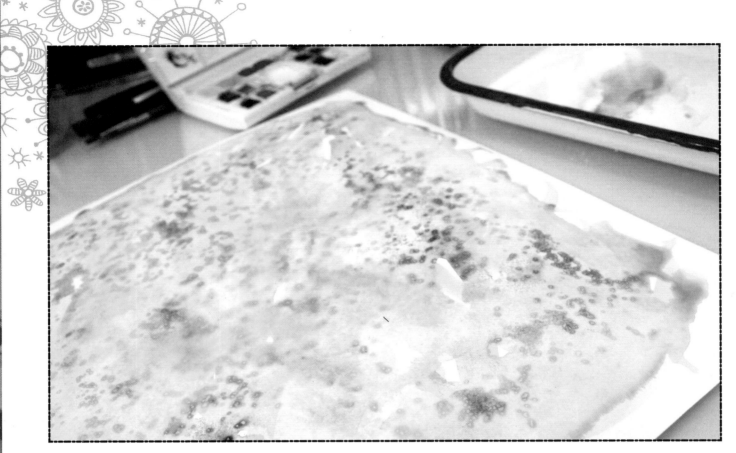

Step 9 On a clean sheet of watercolor paper, repeat steps 5 through 7 to create a color wash covering the entire sheet. Allow to dry completely.

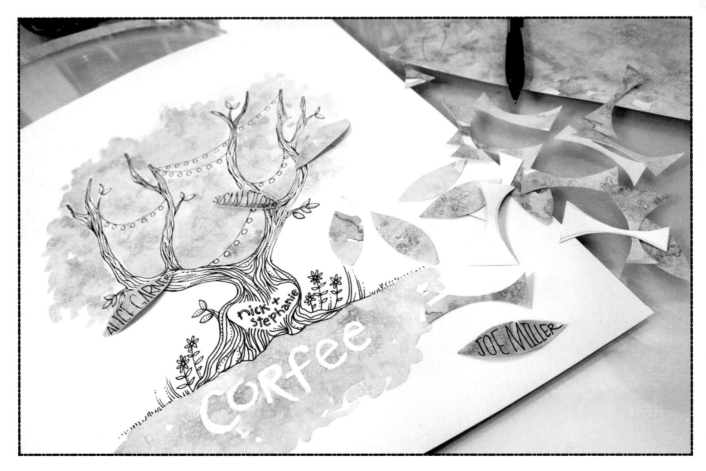

Step 10 From the dry painted paper, cut out as many leaf shapes as there are family members you will include on the tree. Using a black archival ink pen, write one name on each leaf, fitting the letters to the shape.

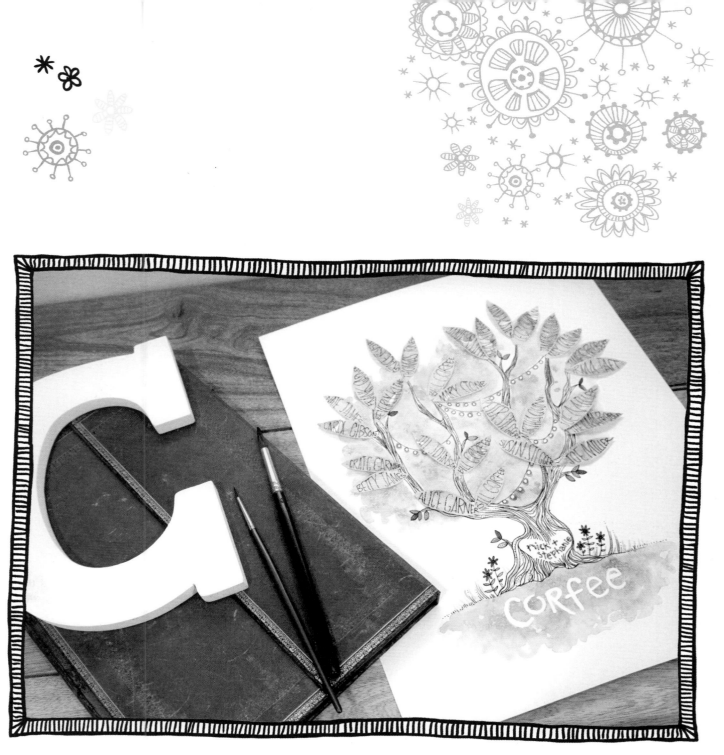

Step 11 Glue the leaves onto the tree, and add any final details and colors to your artwork. Now you have a family history that is personalized to the letter!

Pattern Play

Doodling is a carefree, relaxing style of illustration that can add whimsy to your artwork. Repeating patterns can help convey a theme or jazz up an existing design, but they are also wonderful as standalone projects. Use the ideas below to practice creating your own "intricate" illustrations.

Grow a pattern

Draw a circle approximately 3" in diameter. (You can trace around a glass or lid if you like.) Draw a small dot in the middle of the circle. Then begin "growing" a pattern around it, using doodly elements, such as flowers, hearts, swirls, and curvy lines. Continue to work your way around the center in layers, adding row upon row of detail until the circle is filled.

Build a pattern from a single motif

Draw a 4" x 3" rectangle. Choose a theme and start your pattern in the lower left corner of the frame. Working outward from the corner, repeat the same motif, varying texture, size, and style, until the space is filled. Follow this technique to create any single-motif patterns of your choice, including leaves, circles, and stars.

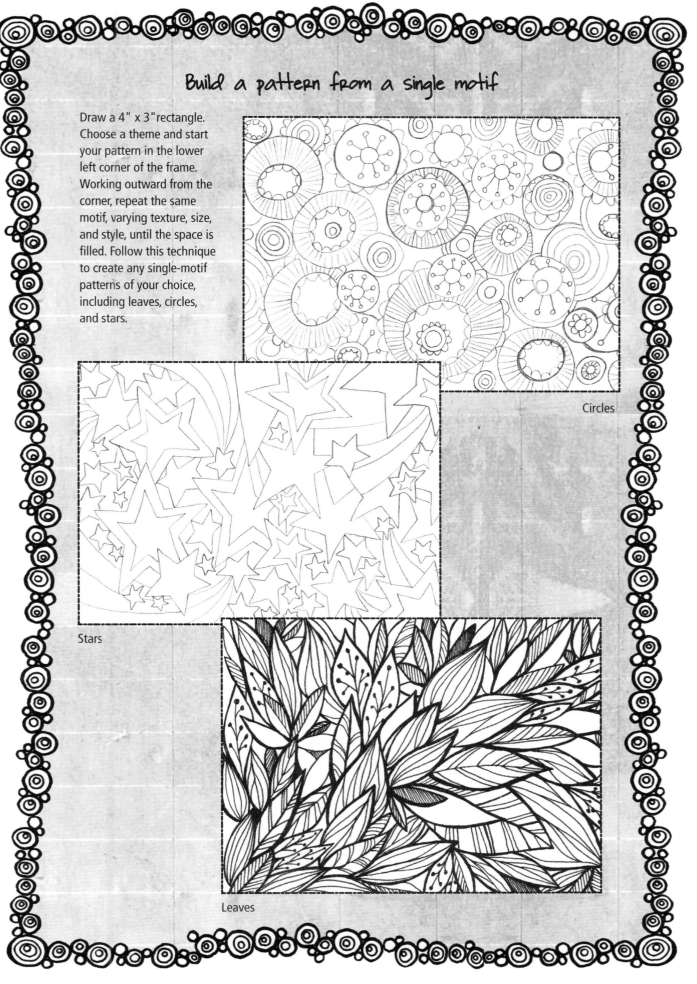

Circles

Stars

Leaves

Drawing Patterns

A butterfly is the perfect subject for practicing intricate designs. Follow the steps below to create your own whimsically patterned butterfly wings on the opposite page.

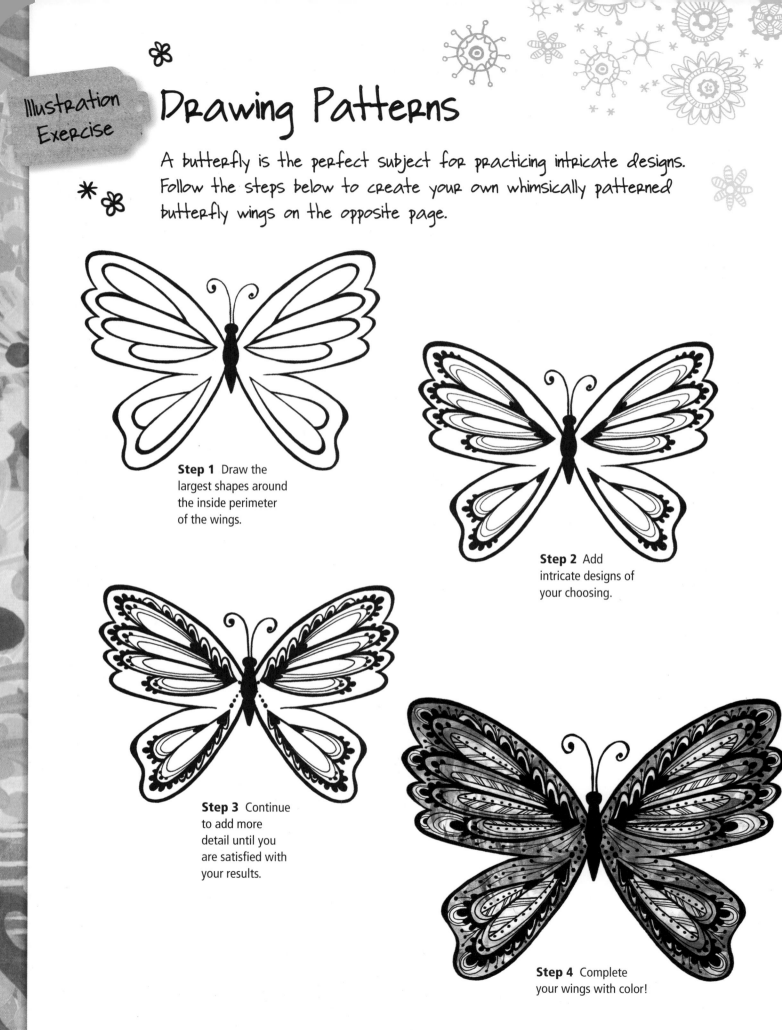

Step 1 Draw the largest shapes around the inside perimeter of the wings.

Step 2 Add intricate designs of your choosing.

Step 3 Continue to add more detail until you are satisfied with your results.

Step 4 Complete your wings with color!

Practice Here!

Practice Here!

43

Mandala-inspired Charms

A traditional mandala is a round design said to symbolize the universe. The graphic is radially symmetrical, and its intricate designs are beautiful and inspiring! Discover how to turn illustrated mandalas into great accessories!

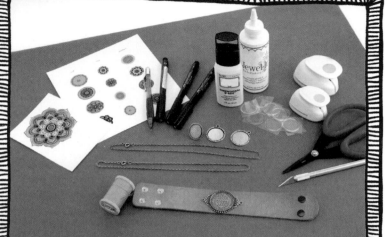

Tools & Materials

- Jewelry blanks with bezel settings
- Jewelry chains, clasps, etc.
- Craft glue
- Scissors, craft knife, or round paper punch
- Quality printer paper
- Heavy cardstock
- Gloss varnish
- Drawing pencils
- Black archival ink pens
- Pre-mixed dimensional resin filler or epoxy stickers
- Preferred color medium such as colored pencils, markers, or paint
- Computer, scanner, and printer

About Epoxy Stickers

Epoxy stickers are clear, domed, rubbery stickers that pop easily over the jewelry bezel. This method is easier than the dimensional filler method, and it requires no drying time at all!

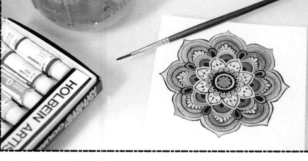

Step 1 On heavy cardstock, draw a mandala design about 3" in diameter. Add color to your design using the medium of your choice. I used gouache paint for rich texture, but you can use watercolors, acrylics, or markers if you like. Once dry, scan the artwork to create a digital file that you can size down to fit your jewelry blanks. Follow the same step to create as many designs as you like.

Step 2 Size your digital files to fit the jewelry blanks. Then print them in color on quality printer paper.

45

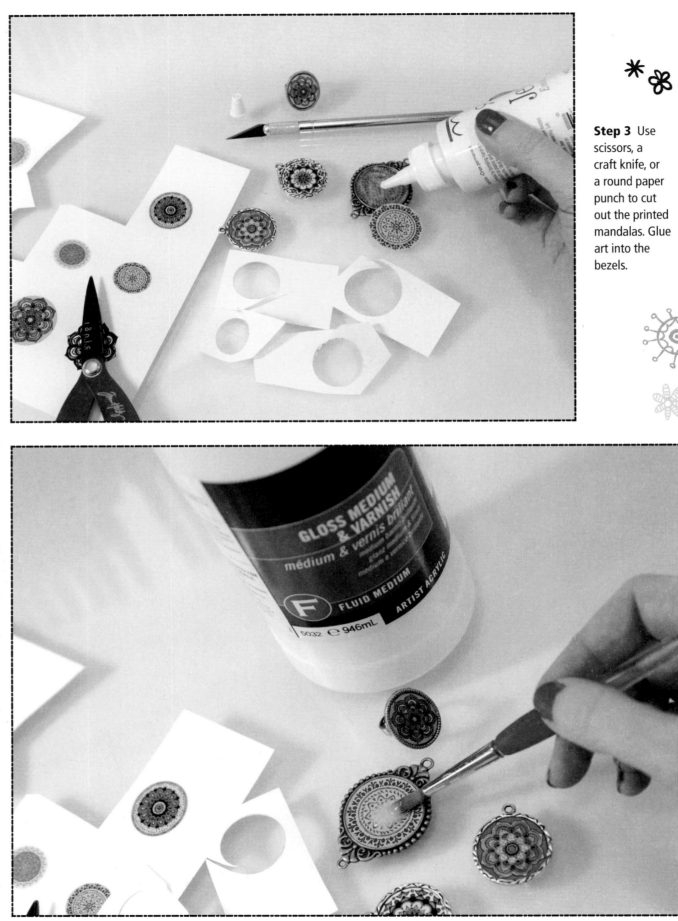
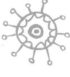

Step 3 Use scissors, a craft knife, or a round paper punch to cut out the printed mandalas. Glue art into the bezels.

Step 4 Seal with varnish to prevent water staining or darkening of the art. (This step is not necessary if using epoxy stickers.)

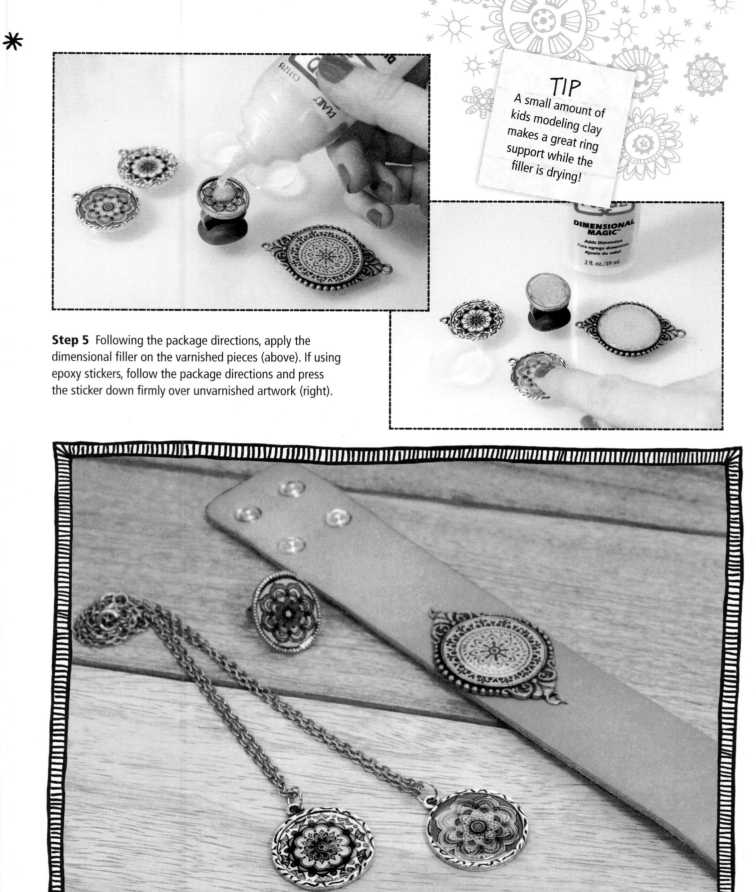

TIP
A small amount of kids modeling clay makes a great ring support while the filler is drying!

Step 5 Following the package directions, apply the dimensional filler on the varnished pieces (above). If using epoxy stickers, follow the package directions and press the sticker down firmly over unvarnished artwork (right).

Step 6 Follow the same steps to create a variety of bezel jewelry, including a pendant, a leather cuff, or a statement ring.

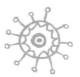

Sketch Artist
Gesture Drawing

Thumbnail sketches and gesture drawings give artists the freedom to work out their ideas before creating a final piece. Gesture drawings are great for learning to master technique. Simply start with broad strokes and large shapes; then build up the forms. Loose movements almost always result in better drawings!

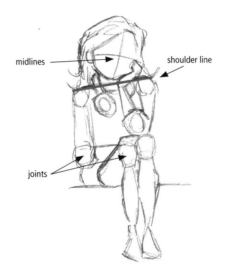

midlines · shoulder line · joints

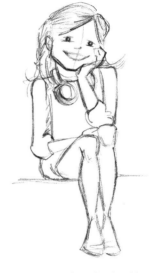

Step 1 Find a photo that shows a dynamic pose, mood, or sense of movement.

Step 2 Loosely sketch the head and draw midlines to denote the facial features. Draw the shoulder lines and add circles for the joints. Fill in the form by connecting the joint circles with lines.

Step 3 Darken the final lines. Use your rough sketch to create a clean drawing.

TIP
When working with kids, be careful not to overdirect them. You'll end up with better shapes, angles, poses, and facial expressions by capturing a genuine moment. If your subject finds it hard to sit still, set up a scene and take lots of photos in sequence. That way you will have a gallery of images to work from later.

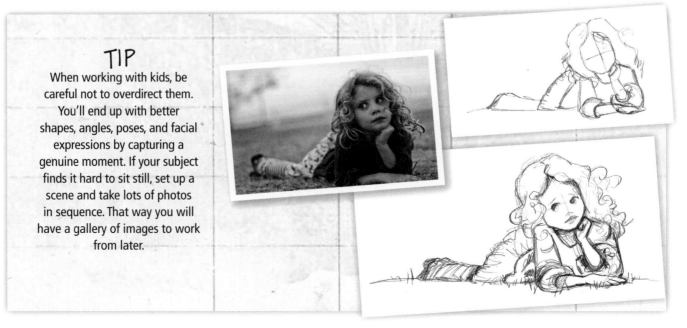

Thumbnail Sketches

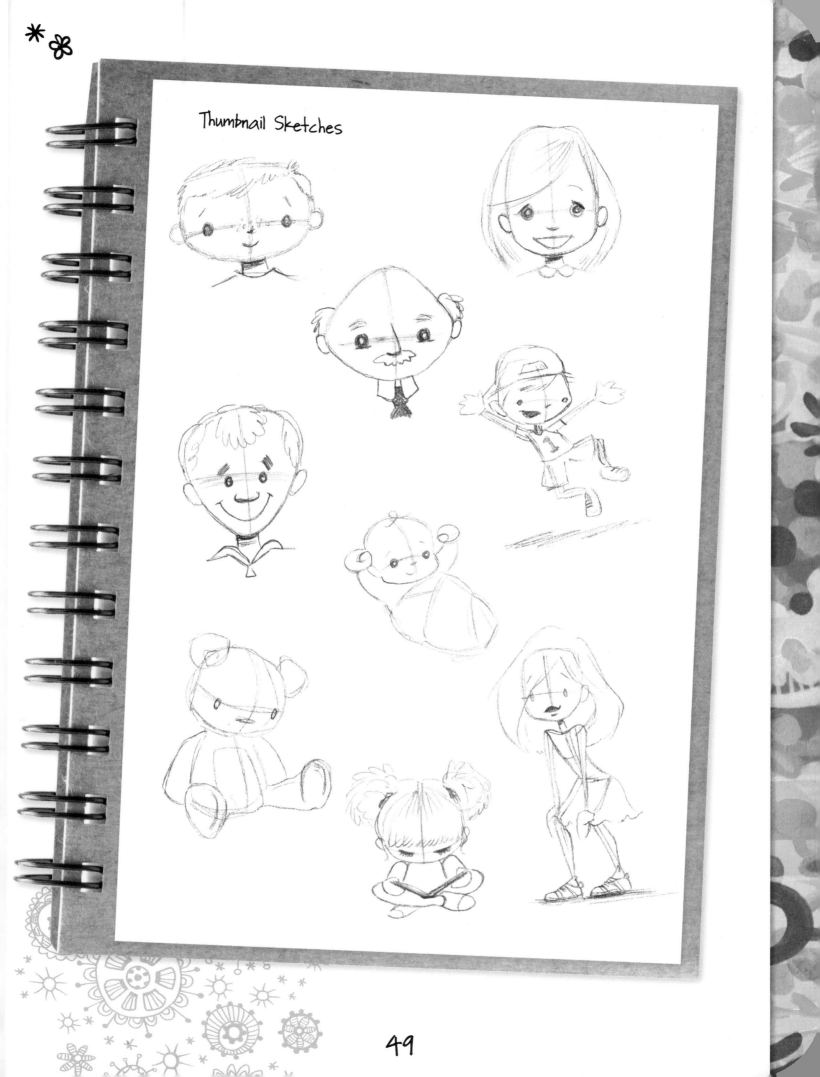

Simplified Faces

Once you've worked out your ideas through gesture drawing, you'll be ready to formalize your character line art. Drawing characters based on real people is an exercise in restraint. Similar to gesture drawing, it's important to only draw lines that are absolutely necessary: a circle for an eye, a curved line for a nose, and a few swirls for the hair. Simplicity also conveys a sense of whimsy.

Defining Features

While your drawings should stay simple, you will still want to highlight the features that make your characters unique, as in the examples below.

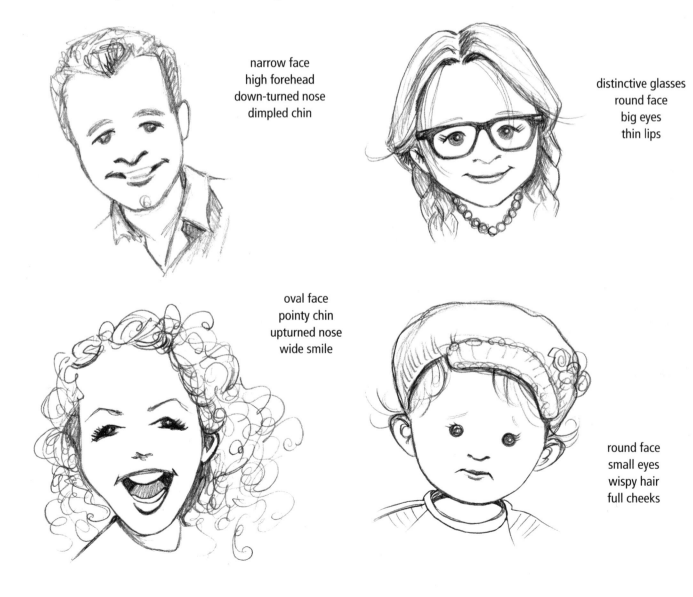

narrow face
high forehead
down-turned nose
dimpled chin

distinctive glasses
round face
big eyes
thin lips

oval face
pointy chin
upturned nose
wide smile

round face
small eyes
wispy hair
full cheeks

Basic Shapes

The faces below were drawn using basic shapes, but notice how each different shape subtly adds depth and a dash of personality to each character.

TIP

When drawing a familiar face, try viewing it as though it were unfamiliar to you. How would you describe it to a sketch artist? Is the face round or oval? Is the hair straight or wavy? The most basic description is usually the best one. Hone in on these basics when you are sketching.

Button nose, wide eyes

Classic heart-shaped face

Talk-show grin, angular jaw

Brawny, cleft-chin

Doe eyes, full lips

Sleepy eyes, bored frown

Large forehead, round eyes, chubby cheeks

Droopy eyes, saggy cheeks

Down-turned nose, friendly smile

Faces & Spaces

Placing facial features where we think they should go is a common mistake among new illustrators. Paying attention to the spatial relationships of your subject's features will help you achieve a real likeness. If your drawing doesn't resemble your subject, you may need to adjust the spacing. Each pair of faces below shares the same shape and features, but the spatial relationships are different. Can you detect the subtle differences? Use the templates on the opposite page to experiment with placing facial features.

Nose and mouth moved lower on face

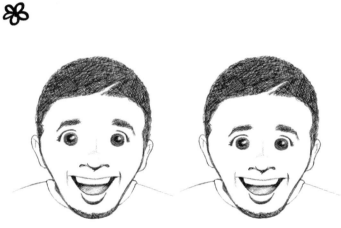

Eyes moved closer together

Eyes set wider apart, and nose/mouth set lower, making the chin appear smaller

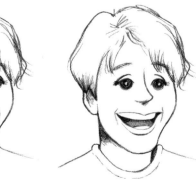

Eyes moved closer together and nose/mouth moved higher, making the chin appear larger

52

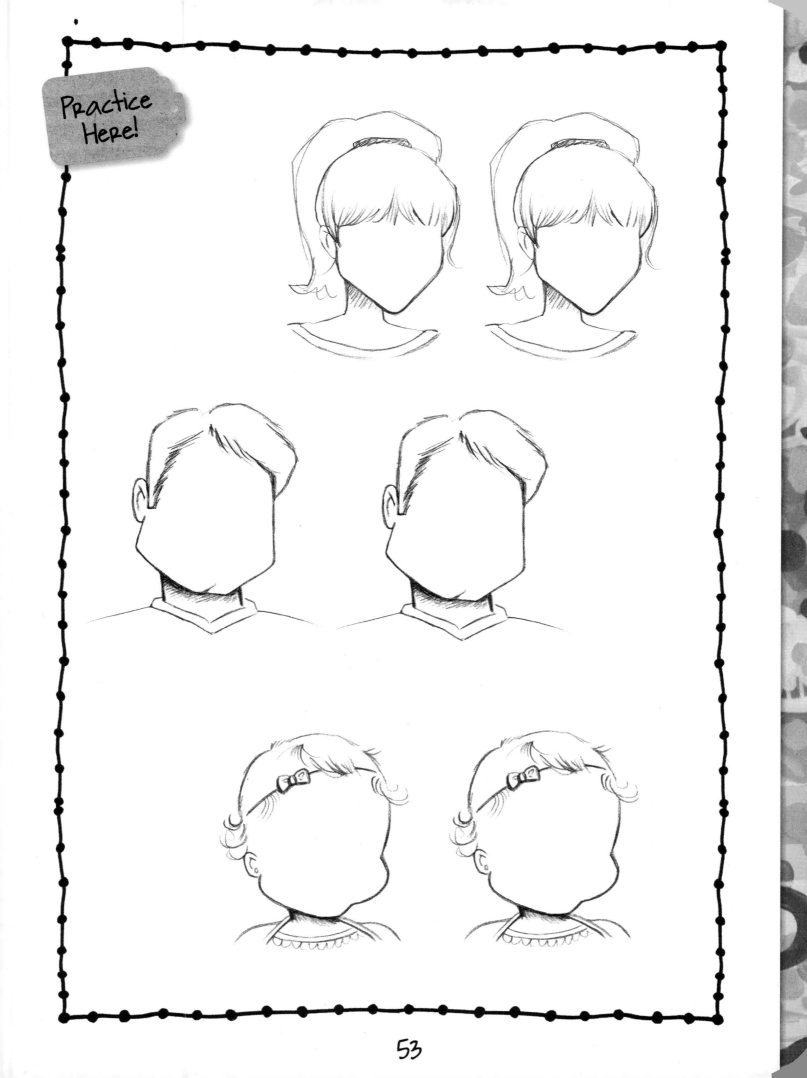

Practice Here!

Custom Notecards

Personalized notecards are perfect for almost any occasion, from making a special announcement to inviting friends and family to a gathering. Depending on your knowledge of digital illustration, there are a number of ways to create custom cards.

Tools & Materials

- Computer, scanner, and printer
- Digital imaging software
- Quality notecards with envelopes
- Archival ink pen or art markers
- Scissors or craft knife
- Quality printer paper
- Double-stick tape or glue
- Assorted colored papers and scrapbooking elements

At the Computer

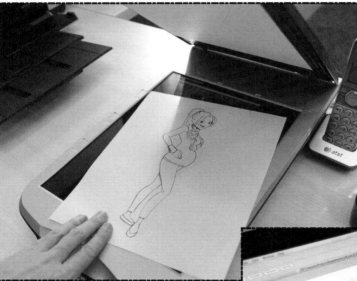

Step 1 Draw a character, object, or scene related to your notecard or invitation. Scan the image into your computer.

Step 2 Use your preferred digital imaging program to add color, fonts, and design elements to your layout.

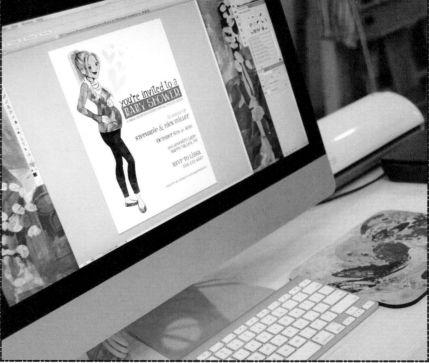

Step 3 Print your image on your notecards.

HAPPY HOUR
BABY SHOWER
a casual celebration before a special little girl arrives

in honor of
STEPHANIE & nick miller

OCTOBER 6TH AT 4PM

103 LOVEBIRD Lane
HAPPY VALLEY, PA

RSVP TO Lissa
555-123-4567

registry at amazon.com/babyregistry

TIP
If you prefer not to print the cards yourself, upload your digital files to an economical print-on-demand site, and your personalized cards will be delivered right to your door!

Step 4 Address your envelopes and mail!

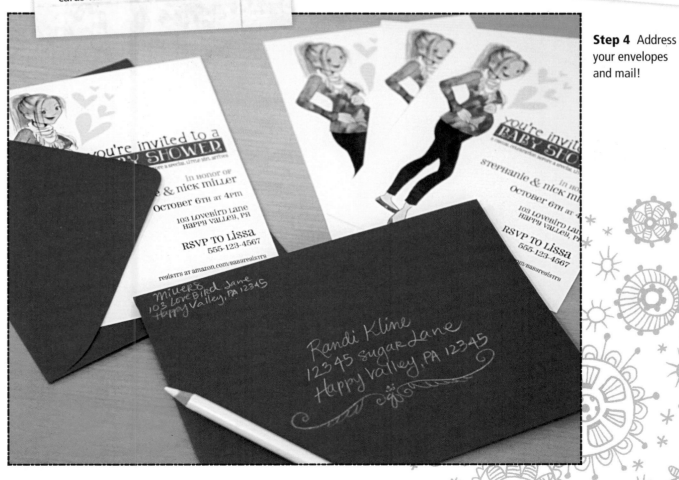

Cut & Paste

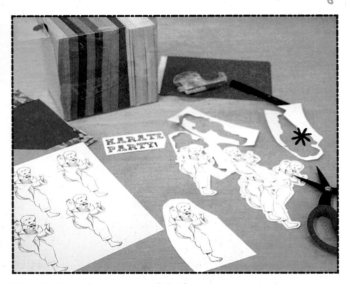

Step 1 Scan your drawing(s) into your computer. Then print the number of copies you'll need to complete your cards. If you don't have a scanner, you can work from photocopies.

Step 2 Use scissors or a craft knife to cut out your drawings.

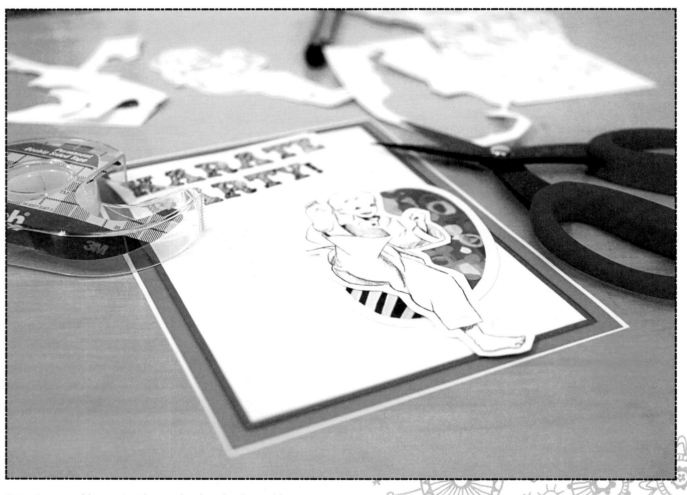

Step 3 Assemble your cards scrapbook style; then add your drawing where desired. Embellish your cards with stamps, stickers, glitter, or anything else you want!

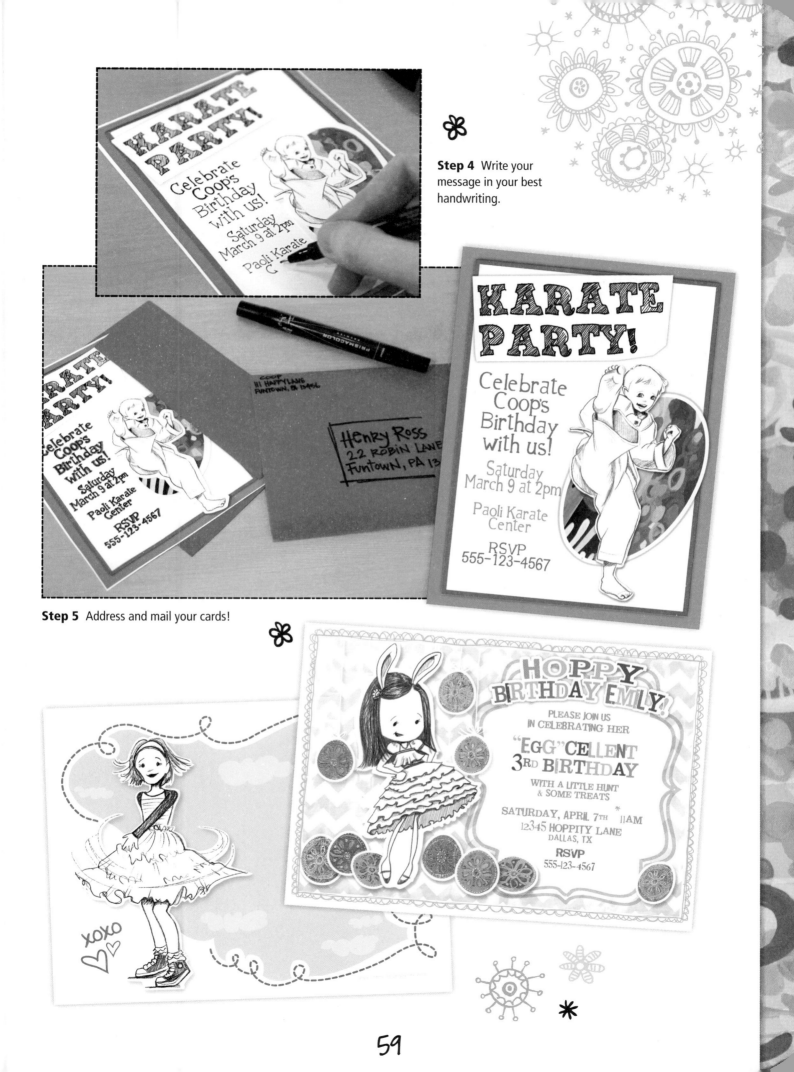

Step 4 Write your message in your best handwriting.

Step 5 Address and mail your cards!

Creativity Prompt

Anthropomorphic Animals

Re-imagining animals with human characteristics is fun. Some artists meld meticulously realistic animal and human illustrations. But often it can be as simple as adding a fedora and eyeglasses to a cartoon mouse. Whatever combination you choose, you're sure to create some clever art. Using the artwork on these pages as inspiration, create your own anthropomorphized animal drawings. Think: dancing, top-hat wearing bear or a musical orchestra made up of parrots—the possibilities are endless! Your only job is to make it fun!

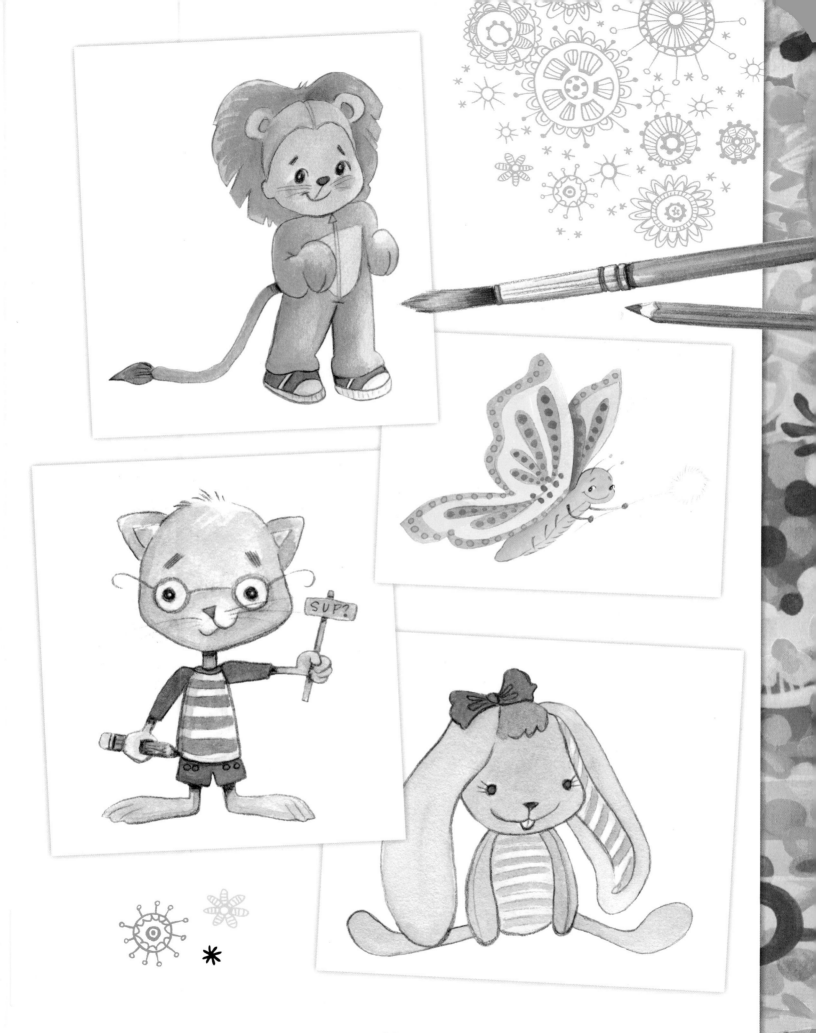

Working Animals

Using the columns on the opposite page, make a list of 10 animals and 10 professions. Then mix and match the two columns, and draw the combinations you come up with on pages 64–65!

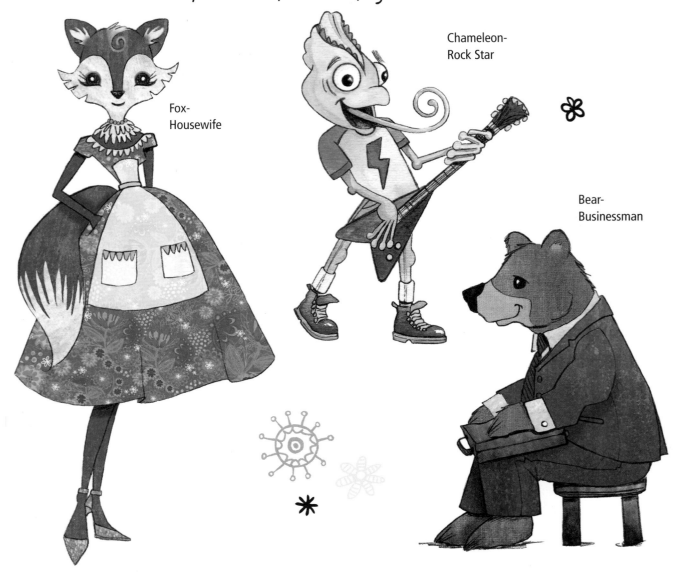

Fox-
Housewife

Chameleon-
Rock Star

Bear-
Businessman

Tips & Tricks

1. Use source photos of animals to get familiar with their most notable characteristics. Add a tail; furry feet; or a long, curly tongue as shown in the examples above. Include color, skin texture, fur, feathers, and other unmistakable features, but leave the rest up to your imagination.

2. Imagine what you'd look like if you dressed as one of these animals for Halloween. Draw what comes to mind. You'd still have a human form, but maybe with a different color of skin, a tail sprouting from your jeans, furry paws, floppy ears, or a snout and fangs.

3. Make scary features friendly by simplifying them. For example, an alligator's jagged rows of gnarly teeth might become a few innocent triangles in a row.

Animals	Professions
1. Chameleon	Rock star
2. Fox	Housewife
3. Bear	Businessman
4.	
5.	
6.	
7.	
8.	
9.	
10.	
11.	
12.	
13.	
14.	
15.	
16.	

Practice Here!

Dog Portrait Pillows

Step-by-Step Project #4

This fun project combines a realistic line drawing of your favorite pooch, jazzed up with quirky human accessories and clothing.

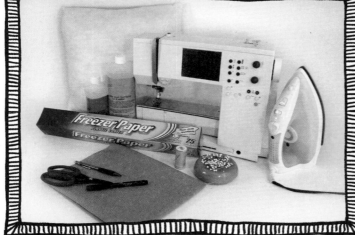

Tools & Materials

- Pencil and pen
- Sewing machine
- Needle and thread
- Fabric
- Scissors
- Pins
- Iron
- Freezer paper
- Bubble Jet Set 2000
- Bubble Jet Set Rinse
- Pillow form or fiberfill
- Computer, scanner, and inkjet printer

TIP

Pre-packaged inkjet-compatible white fabric is available online and in some craft stores if you want to speed up the process. But if you'd like to use a colored or textured fabric, the Bubble Jet Set works like a charm!

Step 1 Select reference photos that will read well as prints. Front-facing, close-up, and staged shots are best.

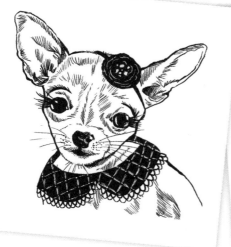

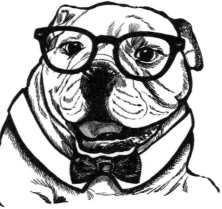

Step 2 Draw your pooch with fun human accessories such as false lashes, bows, eyeglasses, or clothing. Use a lightbox to trace the key lines from the reference photo if necessary.

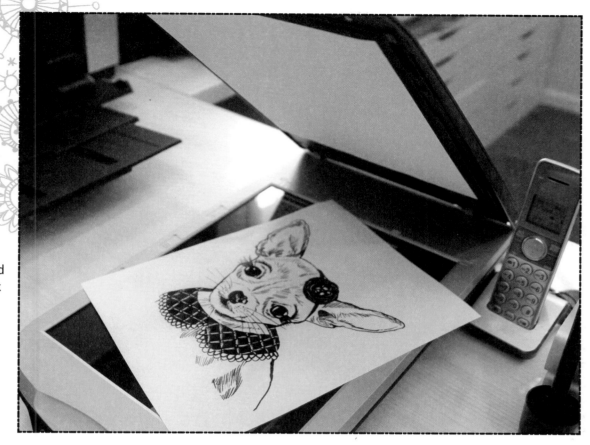

Step 3 Scan and size your artwork for your desired pillow.

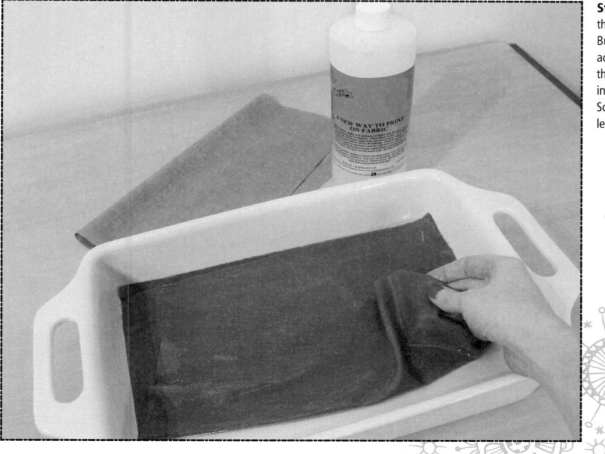

Step 4 Prep the fabric with Bubble Jet Set according to the package instructions. Soak and let dry.

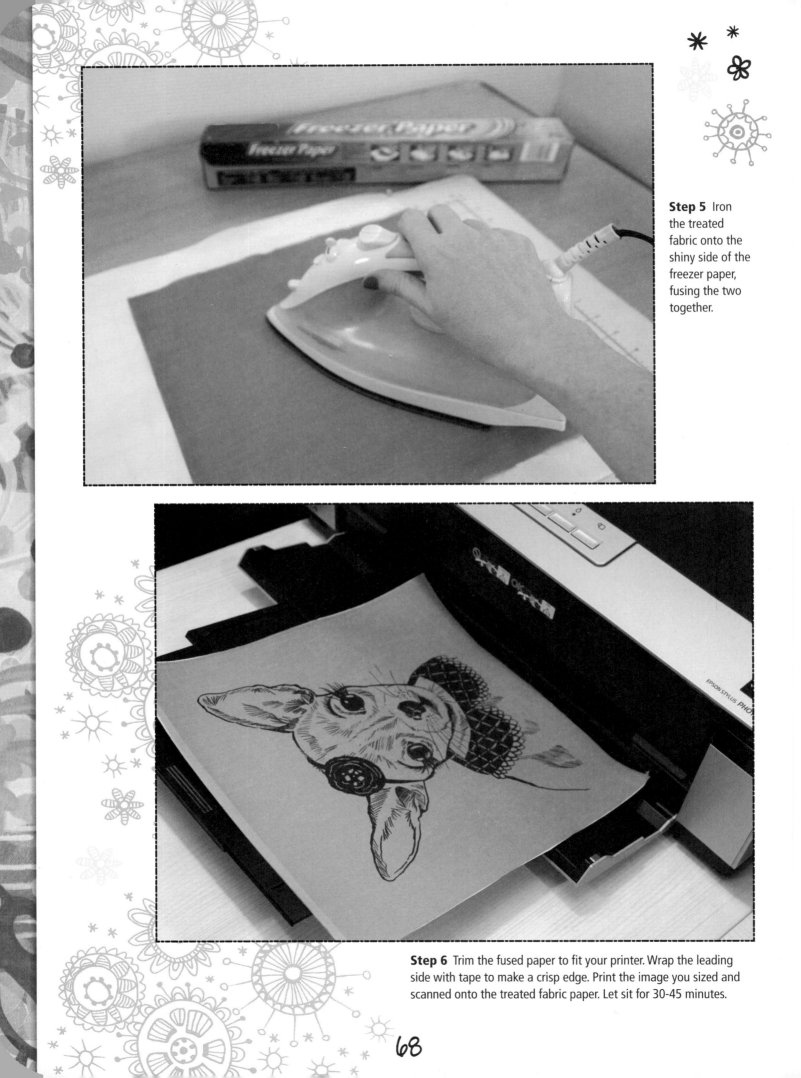

Step 5 Iron the treated fabric onto the shiny side of the freezer paper, fusing the two together.

Step 6 Trim the fused paper to fit your printer. Wrap the leading side with tape to make a crisp edge. Print the image you sized and scanned onto the treated fabric paper. Let sit for 30-45 minutes.

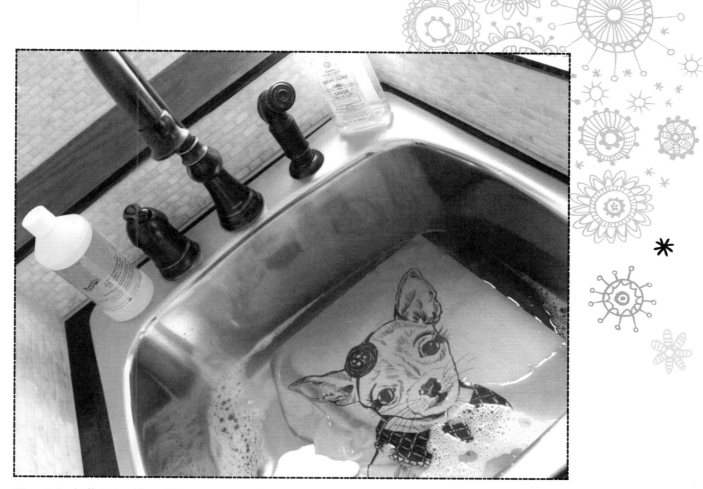

Step 7 Peel off the backing of freezer paper and rinse with Bubble Jet Set Rinse, according to package directions.

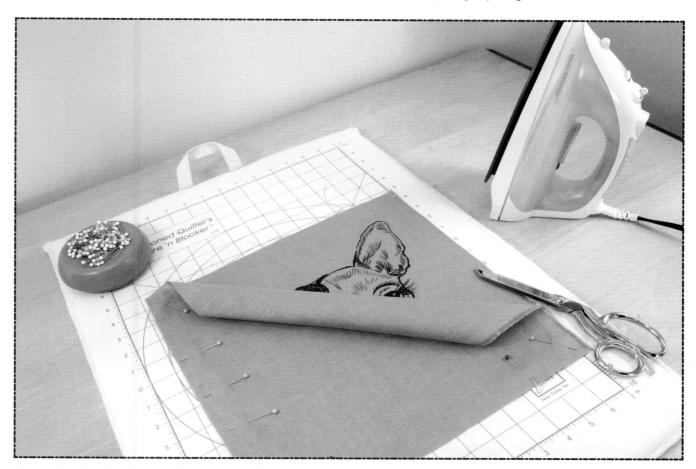

Step 8 Cut the pillow backs and iron. Then pin them with the wrong sides facing together.

Step 9 Stitch around the sides, leaving an opening along the bottom edge for the stuffing or pillow form.

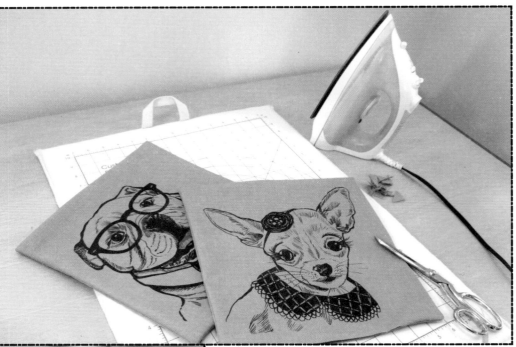

Step 10 Trim the corners on the diagonal. Turn the casing right side out, and lightly press the raw edges in.

Step 11 Stuff the pillow with a form or fiberfill, and hand-stitch the final side to close the opening.

Step 12 Add a few embellishments for fun!

Gilded Ostrich Jigsaw Puzzle

A fancy, feminine anthropomorphic animal illustration is perfect for this quirky puzzle project for grown-ups. I used a specially coated jigsaw puzzle, which I ordered online. After making the puzzle a few times, consider framing it as a conversational art piece to preserve the quality over time.

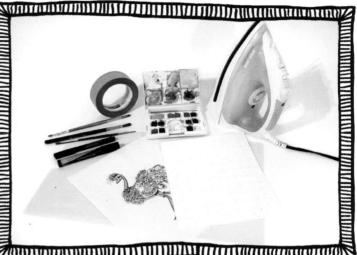

Tools & Materials

- Iron-on jigsaw puzzle
- Super soft inkjet transfer paper
- Watercolor paints and paintbrushes
- Painter's tape
- Watercolor paper
- Black artist pen
- Metallic gold paint pen
- Iron
- Computer, scanner, and printer

Step 1 Make an ink drawing of your animal. Mine is a fancy lady ostrich playing dress-up. Paint a colorful watercolor background on your watercolor paper. Let dry.

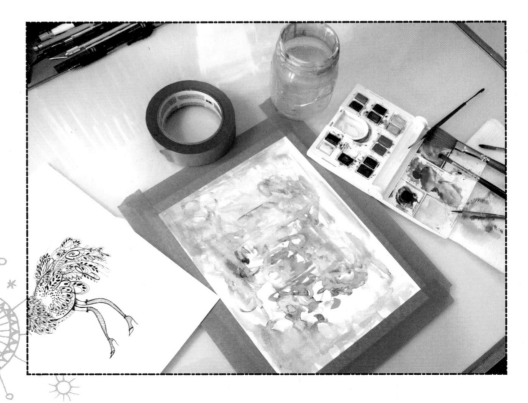

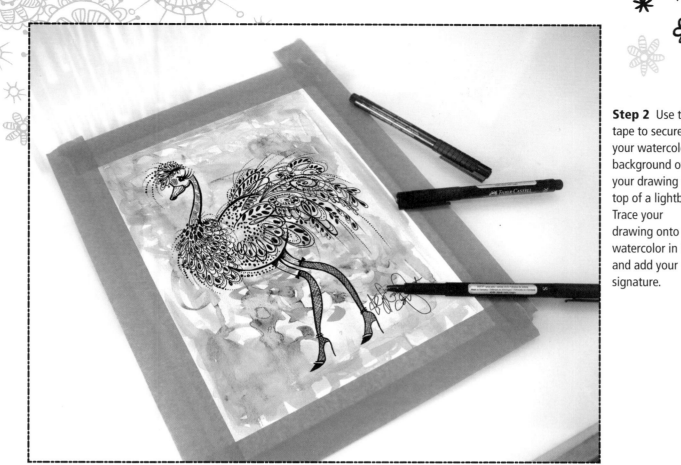

Step 2 Use the tape to secure your watercolor background over your drawing on top of a lightbox. Trace your drawing onto the watercolor in ink, and add your signature.

Step 3 Scan your art.

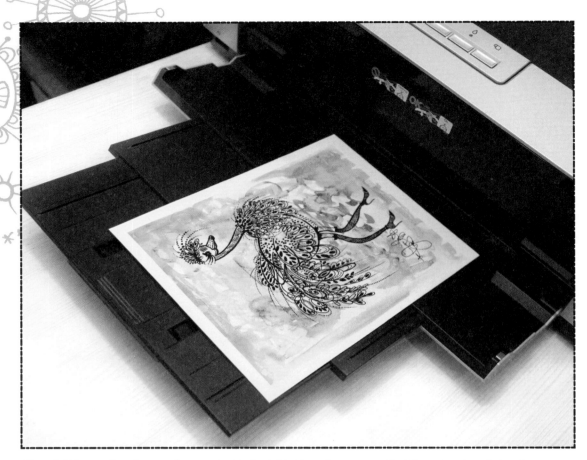

Step 4 Print a mirror image of your art onto the inkjet transfer paper so that the artwork and signature are flipped to the opposite side.

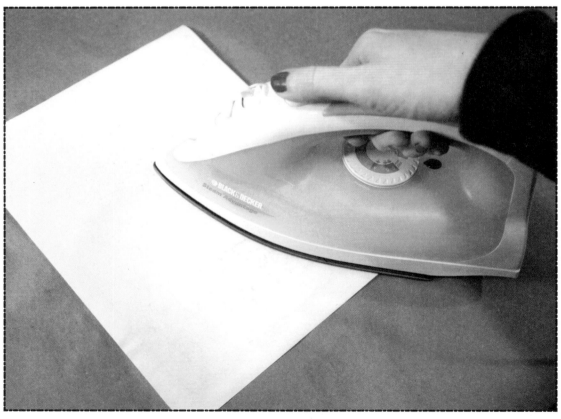

Step 5 Place the transfer paper facedown on top of the puzzle and iron it in place, following the package instructions.

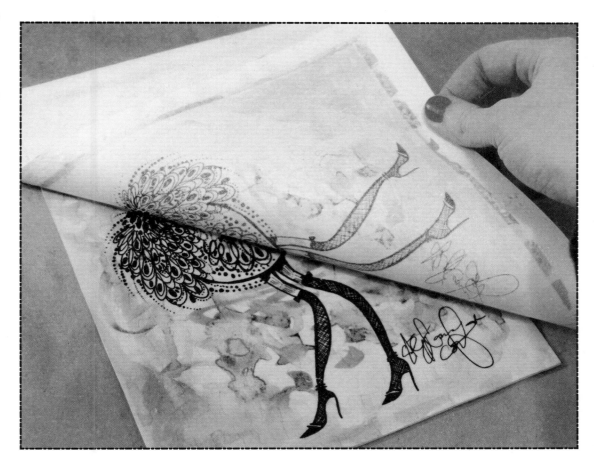

Step 6 While the transfer paper is still warm, gently peel it back to reveal the transferred image on the puzzle.

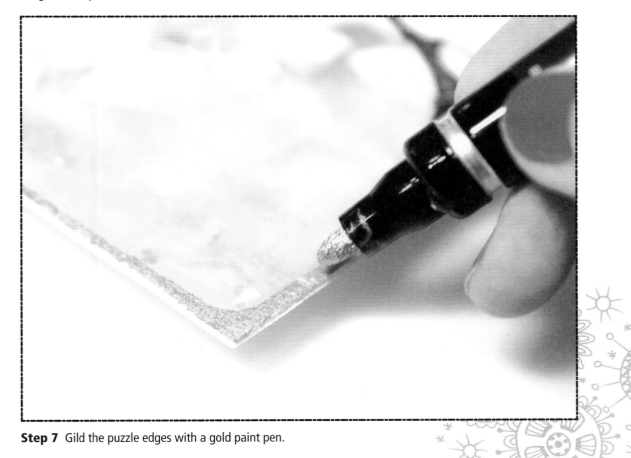

Step 7 Gild the puzzle edges with a gold paint pen.

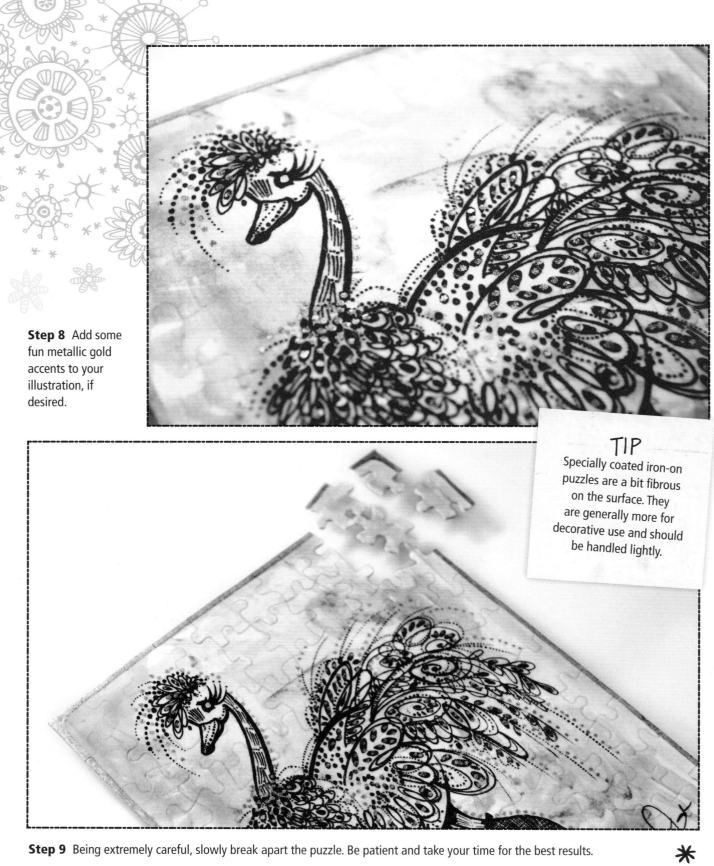

Step 8 Add some fun metallic gold accents to your illustration, if desired.

TIP
Specially coated iron-on puzzles are a bit fibrous on the surface. They are generally more for decorative use and should be handled lightly.

Step 9 Being extremely careful, slowly break apart the puzzle. Be patient and take your time for the best results.

More Puzzle Fun

To make a sturdy puzzle kids can play with, prime an old recycled puzzle and paint directly over its surface. Allow little artists to draw on the surface with colored permanent markers.

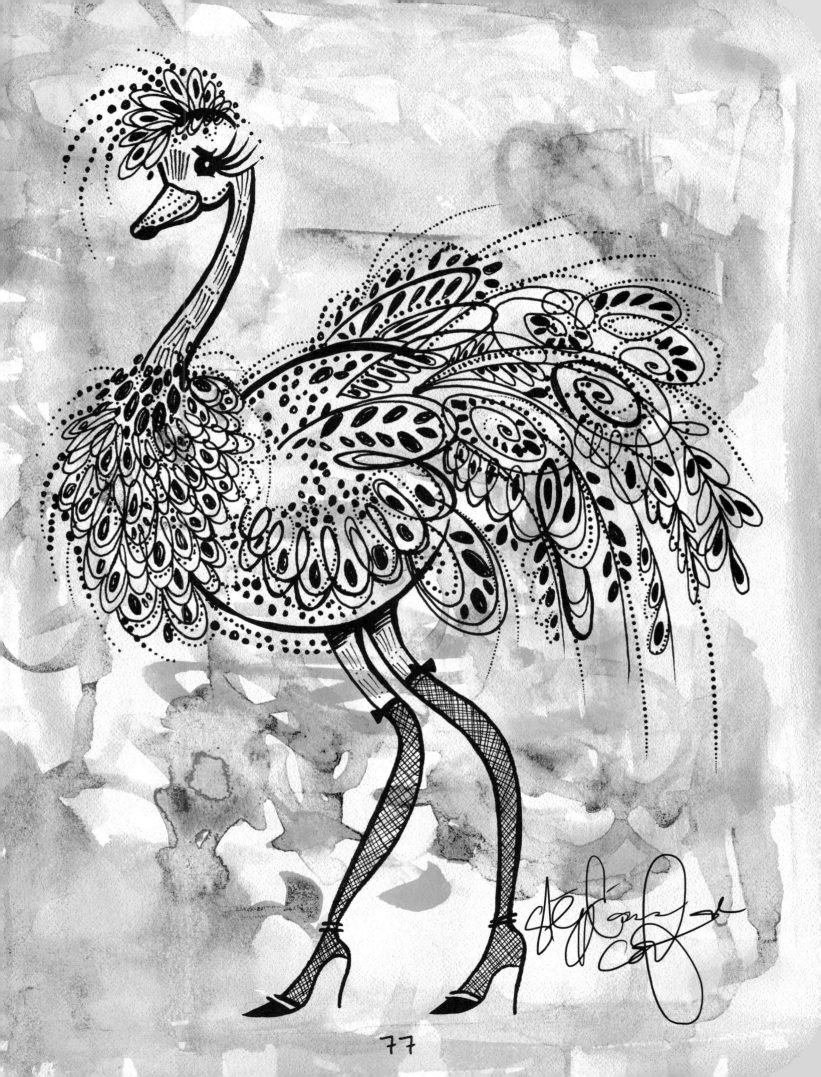

A New Perspective!

Incorporating unique angles into your sketches is great for livening up what might otherwise be relatively dull compositions. For this exercise, it's especially helpful to work from photos. Snap three photos of the same object, each at a different view: one aerial, one side view, and one at an upward angle. Then sketch the object at each angle. Which is the most interesting to look at? Which is the most interesting to draw? Which angle shows the object best?

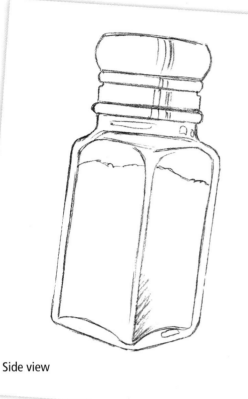

Side view

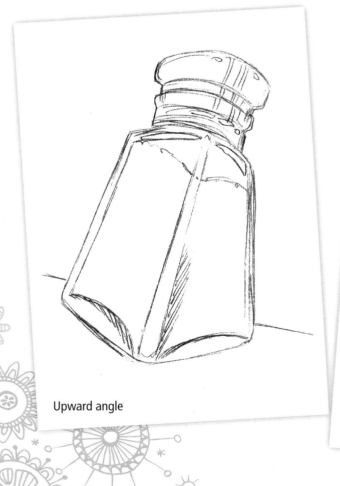

Upward angle

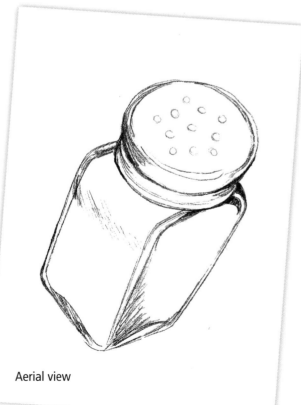

Aerial view

An aerial vantage point helps the viewer to realize the smallness of a child.

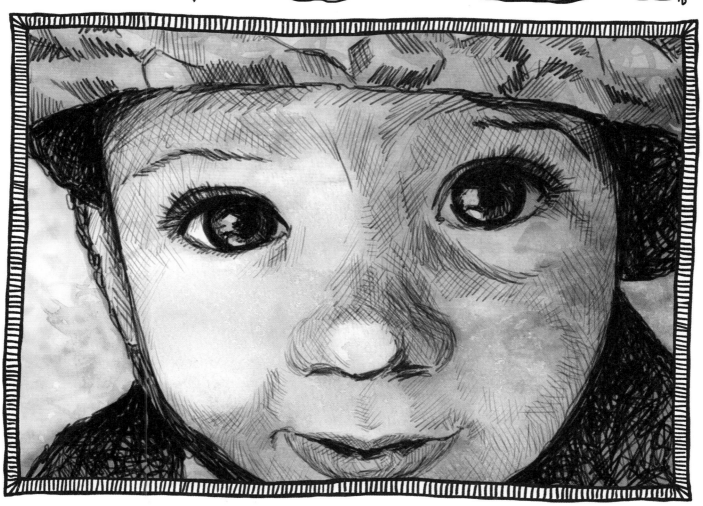

An extreme close-up portrait of a child allows you to focus on capturing precious details, such as the sparkle in the eyes.

Creating Dynamic Layouts

There are many illustration techniques that help create dynamic layouts. Some of my favorites are close-ups, foreshortening, and cropping. You can experiment with these to create action, expression, and motion in a dynamic layout.

Close-ups & Foreshortening

Imagine your drawing area is the lens of a camera. As you capture a scene, some objects will be closer to the lens than others and command attention. Objects in the foreground are sharp and in focus, whereas objects in the background have a softer, "fuzzy" quality, creating depth of field. The sketches on this page show some common close-up and foreshortening techniques. How does each technique make a slightly different statement?

Cropping

Cropping is a great way to make your thumbnail sketches even more useful, whether you crop digitally or by hand. I usually crop until an engaging, well-edited layout emerges. Using a wide-angle, full-body character in the center of the page might be best to illustrate some ideas, but characters and curves that flow off the edge of the page are more engaging and draw in the viewer's eye. Follow the steps below to experiment with cropping.

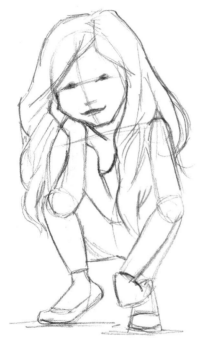

Step 1 Sketch a quick 6" x 8" gesture drawing, using a reference photo to guide you.

Step 2 Cut a 4" x 6" window in a piece of 8.5" x 11" cardstock. Move the window over your sketch, rotating and shifting until you find the most visually interesting crop.

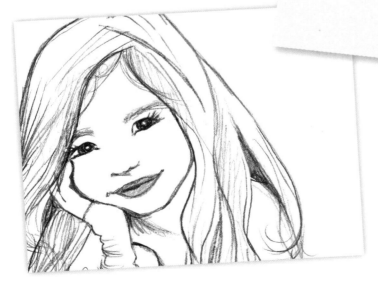

Step 3 Create a more finished drawing using the cropped section as your guide.

Capturing Action

Illustrating characters or objects in motion is another technique for creating dynamic layouts. Using the illustrations below as inspiration, sketch the scene described in each sentence on pages 84-85, using the angles for dynamic layout.

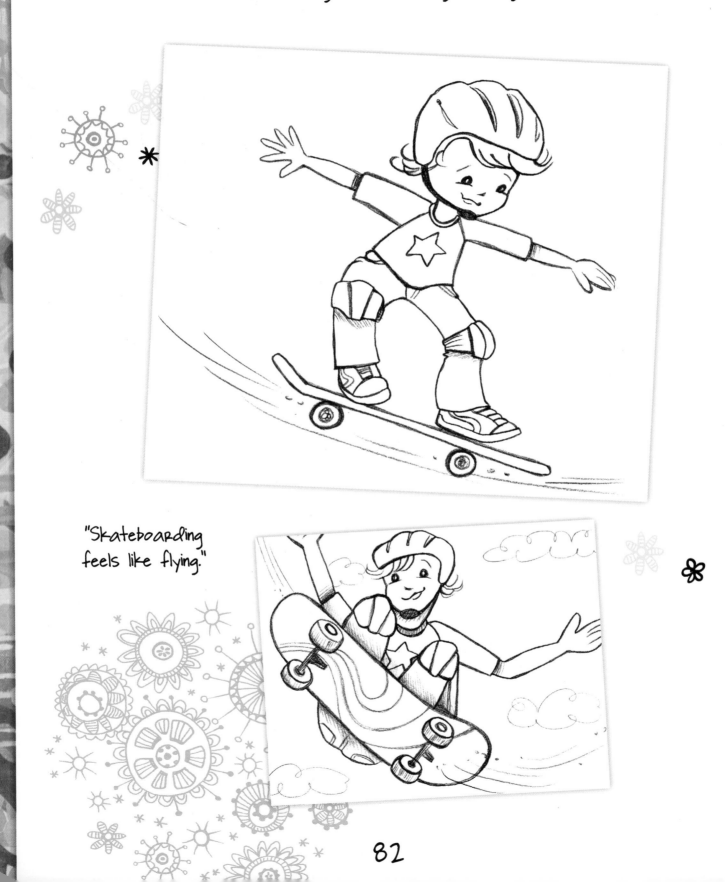

"Skateboarding feels like flying."

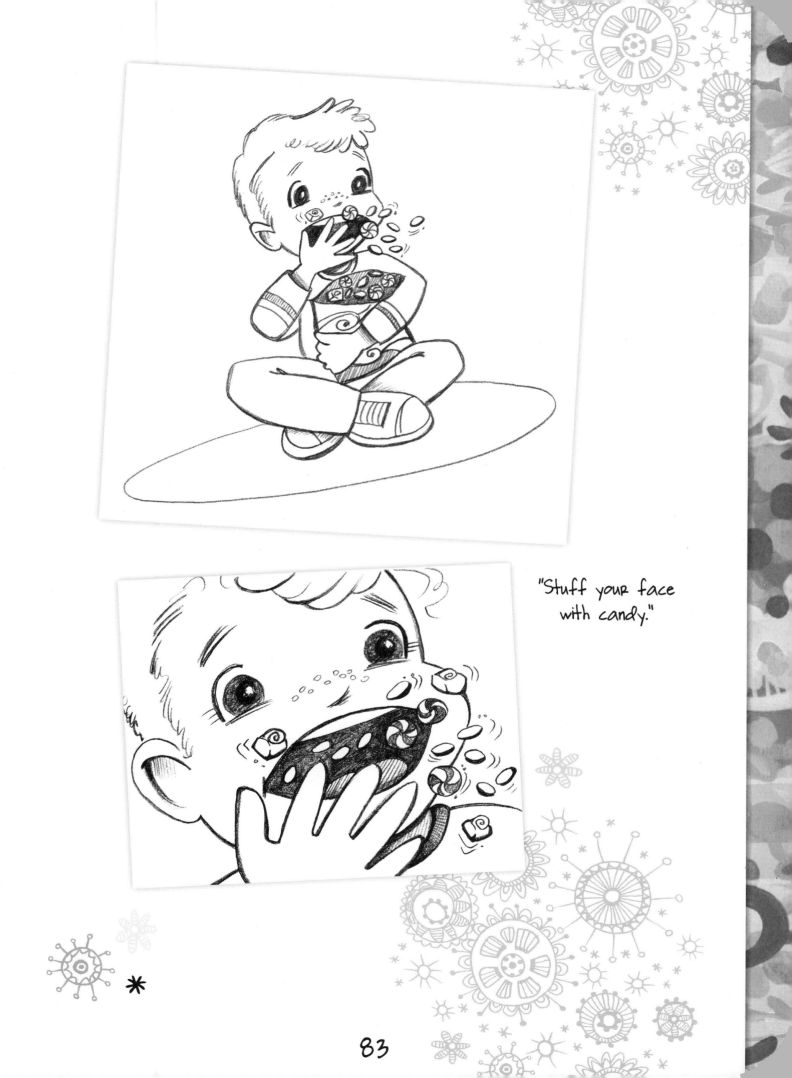

"Stuff your face
with candy."

*

Foreshortening

Close-up

Wide angle

Practice Here!

Family Shadow Box

Now you can utilize dynamic layout techniques and immortalize your family in a memorable way while you're at it!

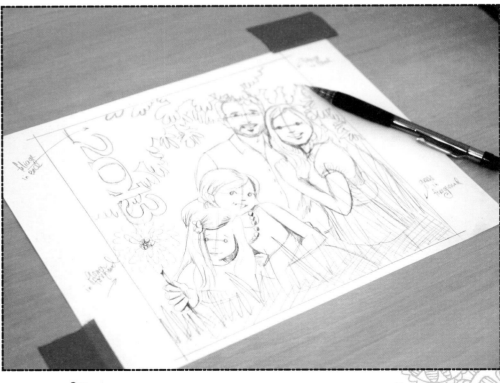

Tools & Materials

- Shadow-box frame
- Foam core strips
- Glue gun or foam tape
- Double-stick tape
- Pencil
- Pen
- Craft knife or scissors
- Watercolor paints
- Paintbrush
- Heavyweight colored papers (e.g. scrapbook papers)
- Tracing paper
- Low-tack spray adhesive

Step 1 Draw a rough sketch of your family, sized for the frame. Keep layering in mind as you sketch. For example, sketch foliage in the background, grass in the foreground, and characters in the mid-ground. Each layered element will be transferred to a colored paper. Make a photocopy of your sketch and set aside.

Step 2 Place tracing paper on top of your sketch. Trace around the first "layered" element. For example, the little girls being traced at right will be one layer. The parents behind them will be another layer, and so forth. Use separate sheets of tracing paper for each individual layered element.

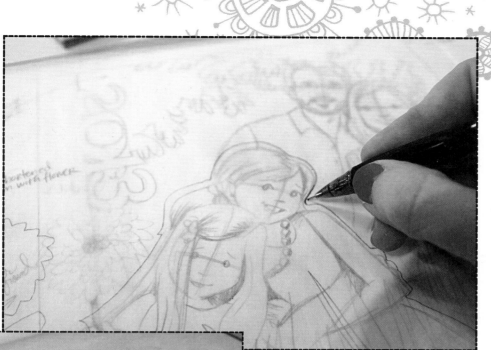

Step 3 Before going any further, make a cheat sheet using your photocopied sketch (see top left of image), so that you know in advance what color to assign each layer. Characters look best on light-colored paper, whereas background elements, such as trees and grass, look best on darker papers. Layer each piece of tracing paper with its assigned color of paper, using low-tack spray adhesive to affix the pieces together.

Step 4 Begin cutting out each traced element from the paper. Using scissors or a craft knife, trim around the traced outline. Then peel off the tracing paper.

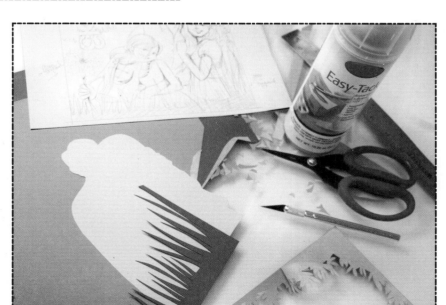

Step 5 Transfer your drawings onto their color-paper layers. You may opt to use a lightbox for this purpose.

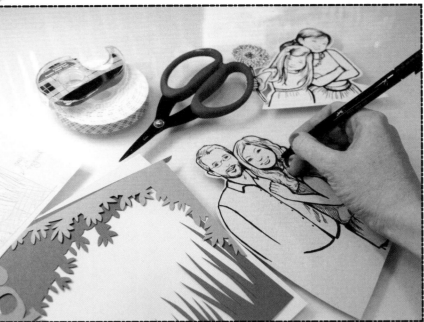

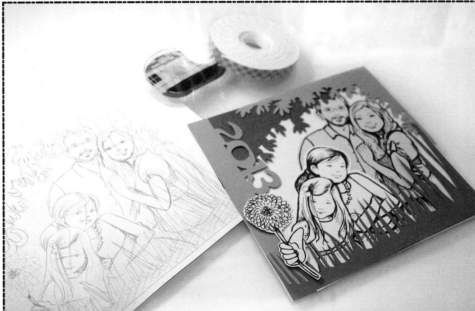

Step 6 Stack your elements from background to foreground to check placement.

Step 7 Use your watercolors to add a few pops of color to jazz up one or more elements of your choice.

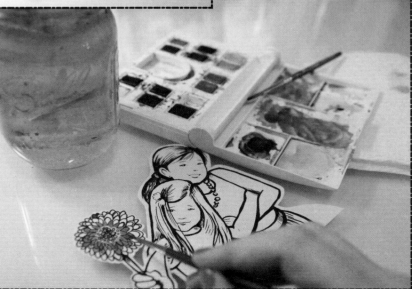

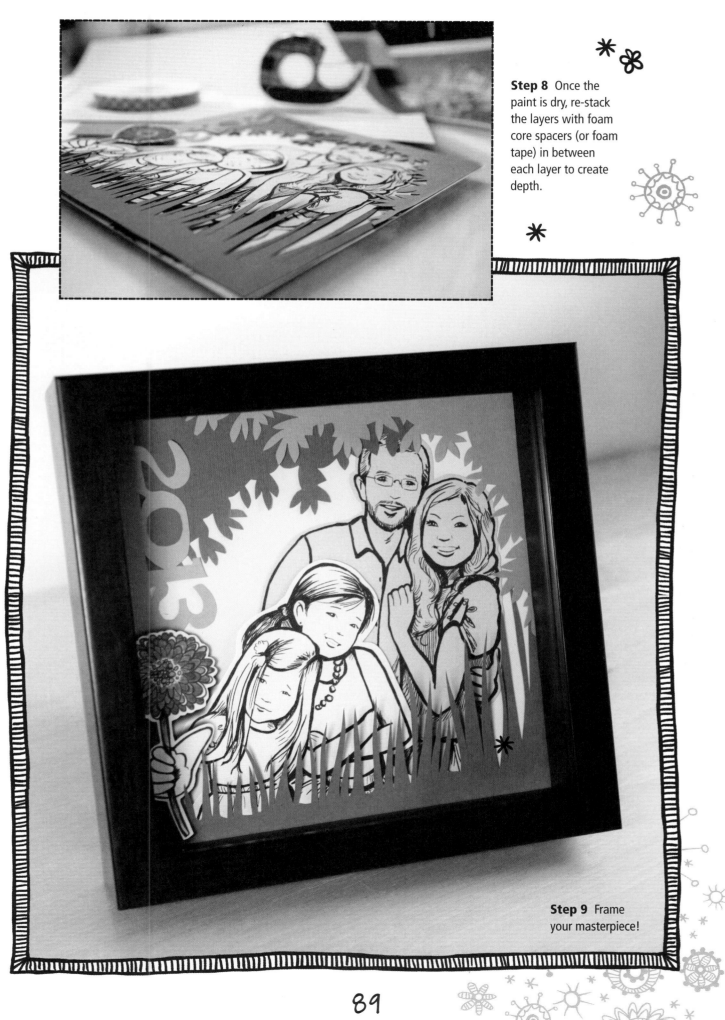

Step 8 Once the paint is dry, re-stack the layers with foam core spacers (or foam tape) in between each layer to create depth.

Step 9 Frame your masterpiece!

Free Stylin'

Being an artist is all about sharing your creativity and one-of-a-kind perspective. As an illustrator, you do this by developing a signature style. Without overthinking the process, draw a monster representative of your personal style, making sure it captures the essence of your artistic expression. Using the steps below as a guide, draw your little critter on the opposite page.

Step 1 Make a quick gesture drawing to establish proportion, scale, and shape.

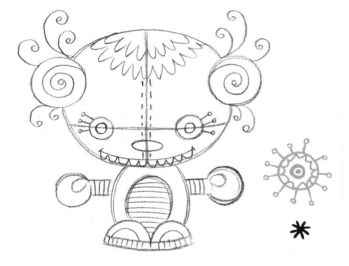

Step 2 Add details, decorations, and stylistic quirks.

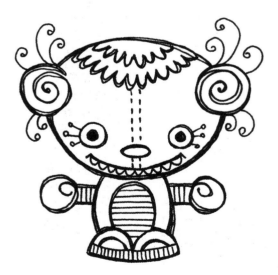

Step 3 Refine your sketch lines and ink the drawing.

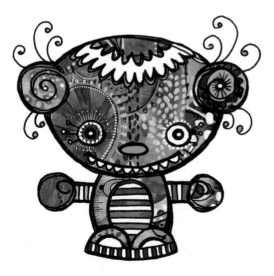

Step 4 Add color, textures, and patterns.

Practice Here!

Honing Your Style

Your style is your innate, organic ability to turn any drawing into an illustration uniquely your own. Artists often discover their styles by simply paying attention to their basic likes, including favorite aesthetics, colors, and textures. Using the source photos and accompanying illustrations as inspiration, on the opposite page, create your own interpretation of the styles suggested below. Take as much or as little artistic license as you like. Think about the details, flourishes, shapes, and signatures you'd like to be recognized by. How can you style a simple drawing so that it feels like yours?

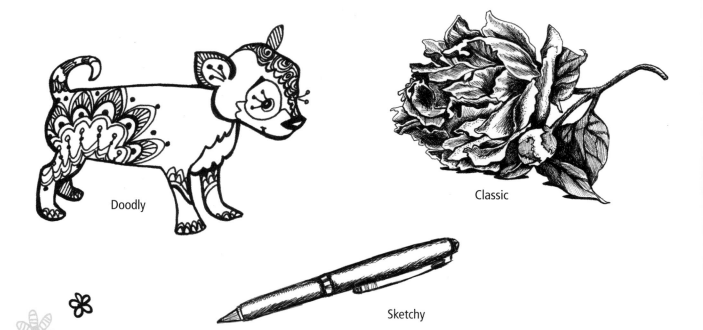

Doodly

Classic

Sketchy

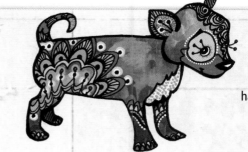

Doodly

Classic

Sketchy

What's your style?

Signature Style Revealed

Reflect on your drawings and ask yourself: Which style was the most fun? Which came the most naturally? Which do you personally like the most? Which did you execute the best? The answers to these questions will reveal your style tendencies.

95

Celebrating Creativity

Adding an illustrative touch to a family photo can be an opportunity to share your style and tell a unique story about your loved ones. This project will help you create personalized, two-dimensional props to use for creative family portraits. The idea is to celebrate your family's creativity in a fun, tongue-in-cheek way!

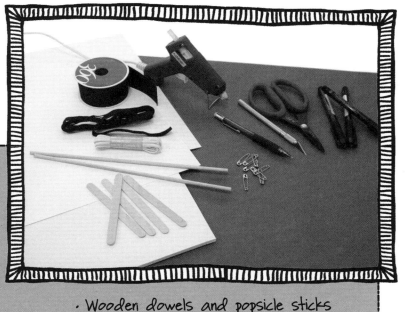

Tools & Materials
- Mat board or poster board
- Foam core for added stability (optional)
- Pencils
- Black permanent markers
- Paints, markers, and colored pencils to add color (optional)
- Craft knife or scissors
- Wooden dowels and popsicle sticks
- String, elastic, safety pins, and ribbon for adhesives
- Hot glue gun and glue sticks

Step 1 Jot down a list of fun props that relate to the theme of your photo shoot or to your family's personality. I chose a "dapper gentleman's theme," complete with boutonnieres, bow ties, moustaches, and flowers (for the lady of the house, of course). Draw each item on plain paper, creating a consistent collection and using your own distinct style.

TIP
This style works great in black and white. Choose the color palette that best fits your theme.

Step 2 With the help of a lightbox, use a pencil to lightly transfer your drawings to the poster board. Then trace over your lines with a marker or pen.

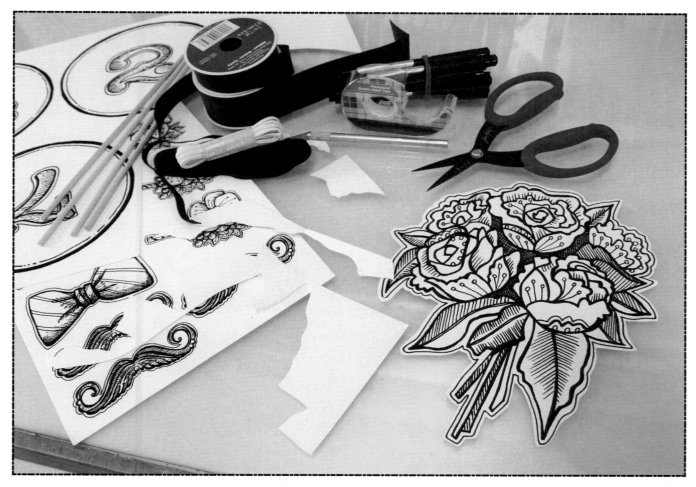

Step 3 Add color now if you're planning to. Trim the illustrations just outside the marker lines.

Step 4 Follow the instructions below to assemble your pieces.

Frame: Hot glue a foam core brace to the back of the frame to keep it from curling and bending.

Bow Tie: Tie a soft piece of elastic into a loop and hot glue it to the back of your bow tie. Ensure it's snug, but still comfy to wear.

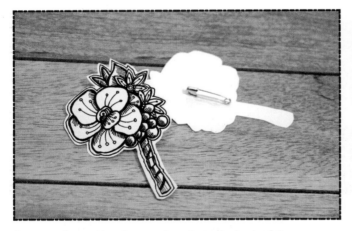

Boutonniere: Hot glue a safety pin to the back of the boutonniere.

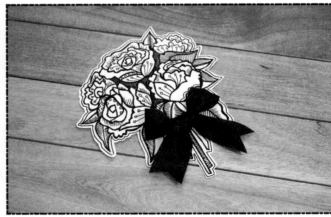

Bouquet: Add a ribbon to your bouquet with a bit of hot glue to amp up the character of your photograph.

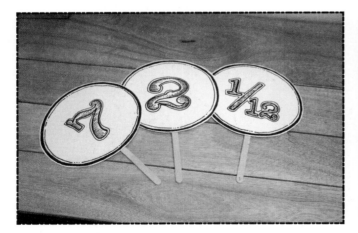

Paddles: Glue craft store popsicle sticks to the back of the age badges to create paddles, which will date your photos with charm and whimsy.

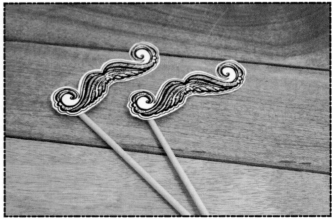

Moustaches: Add a dot of glue to the backside of each moustache and adhere them to thin wooden dowels.

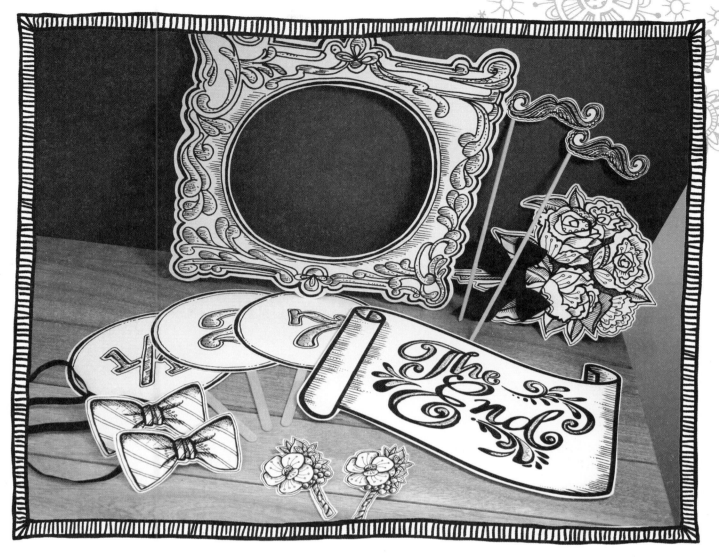

Step 5 After your family photo shoot, display your signature creations for all to see and admire!

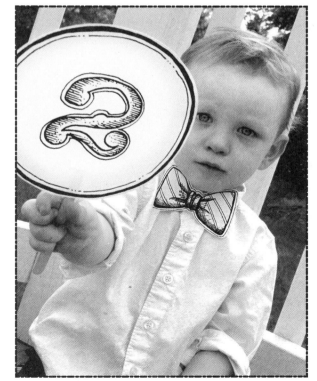

99

Telling Stories

Layouts with dynamic characters and details add depth to a story and can fill in the blanks for the reader. Discover how to bring your own vibrant characters to life through illustration!

Two-Sentence Story Illustration

Think of a simple before-and-after scenario from a classic fairy tale, such as "Jack and the Beanstalk." Choose a moment in the story with a dramatic change. Sketch a simple line drawing depicting your character in the "before" and "after" scenes, as shown below. The idea is to create a dynamic shift from one frame to the next, varying the angle, pose, or layout.

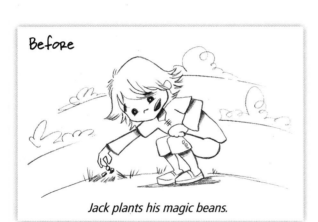

Jack plants his magic beans.

This is a standard angle without a lot of drama to reflect the calm moment in the story.

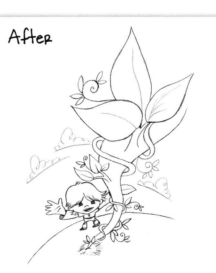

Jack celebrates his 100-foot-tall beanstalk!

Using an aerial perspective amps up the dynamic shift in this second image.

Story Illustration Tips

1. Move the Story Forward with Dynamic Movement
Think of reading a novel. There are no pictures to accompany the words, but as you move through the story you inevitably create scenes in your mind's eye. The same principle applies in illustration. Focus on the action-packed moments—the turning points that would tell your tale the best if there were no words!

2. Continuity of Proportion & Features
In order for a reader to engage with your characters, your character drawings must be consistently recognizable from page to page, regardless of angle or facial expression. Maintaining character continuity across multiple illustrations is achieved through such elements as hair, clothing, proportions, and a consistent representation of personality.

3. Developing Characters with Details
Rich detail in your illustrations adds depth to a story and helps convey scene and personality. For example, I might add daisies in a character's hair to show she loves nature.

Illustrate a Mini Story

Now make up your own two-sentence before-and-after story and illustrate it below.

Before

After

Creating Story Characters

The goal of character illustration is to create a distinctive look that elicits emotion from your reader. Creating a visual blueprint that maps out your characters' proportions, features, clothing, and quirks creates a helpful reference as you draw.

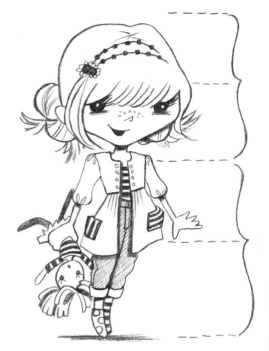

Step 1 Weave personality into the character's fashion sense, hairstyle, and body language. Draw at least two distinct details—such as a fancy barrette and mismatched socks—and create a small sidekick like an animal or a doll.

TIP
Be specific—think about your character's personality. Don't be afraid to include characteristics of real people you know!

Step 2 Label the blueprint thoroughly, describing each element.

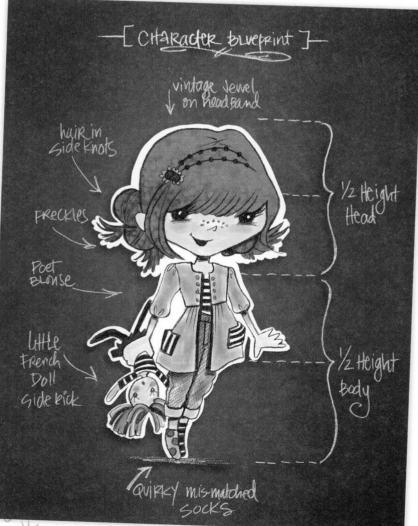

[CHARACTER Blueprint]

vintage Jewel on headband

hair in side knots

Freckles

Poet Blouse

Little French Doll Sidekick

½ Height Head

½ Height Body

quirky mis-matched socks

Keeping a Character Consistent

Following the steps below, practice maintaining continuity in a character by telling the following mini-story in three illustrations. Use the practice areas on pages 104-105 to draw your illustrations.

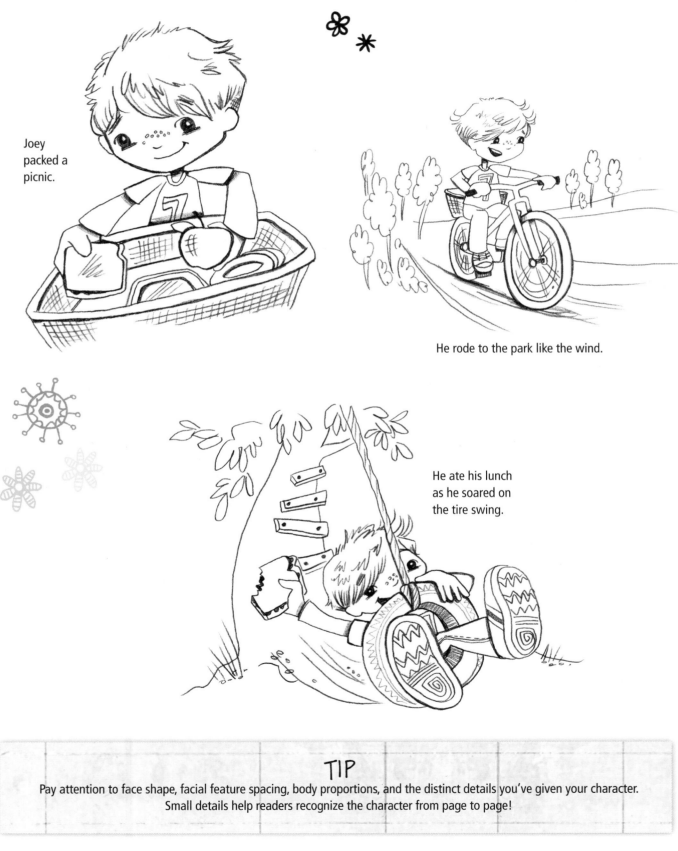

Joey packed a picnic.

He rode to the park like the wind.

He ate his lunch as he soared on the tire swing.

TIP
Pay attention to face shape, facial feature spacing, body proportions, and the distinct details you've given your character.
Small details help readers recognize the character from page to page!

103

Practice Here!

Personalized Triptych

Step-by-Step Project #8

Techniques for illustrating a character with depth, continuity, and personality can be used for multiple types of projects, whether personal or professional. This project shows how to capture a child's personality in a personalized art triptych "story," and makes a great keepsake or gift.

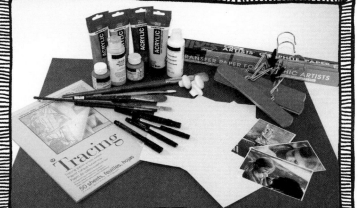

Tools & Materials
- 3 wooden pants hangers
- 3 plain white knobs
- Source/inspiration photos
- 3 sheets of watercolor paper
- Drawing paper or sketchbook
- Drawing pencil
- Acrylic paint in multiple complementary shades
- White acrylic paint
- Paintbrushes
- Tracing paper
- Graphite transfer paper
- Black marker or pens

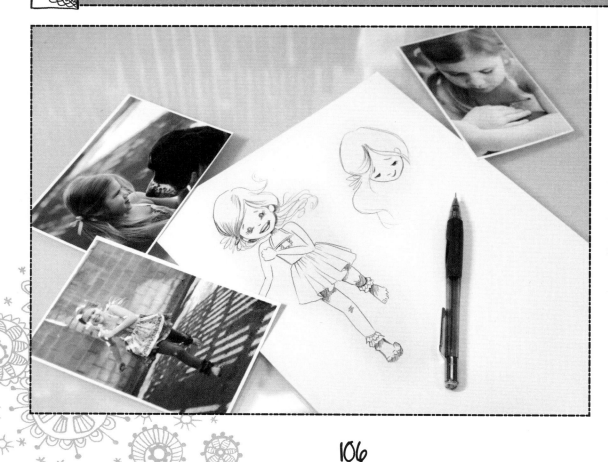

Step 1 Take several photos of your subject that capture a variety of poses, angles, and expressions. Using the photos as reference, create drawings of each pose. Remember you are creating a "character;" don't strive for an exact likeness.

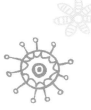

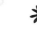

Step 2 Using broad, sweeping strokes, apply analogous color combinations of acrylic paint to each of the three watercolor sheets. Allow to dry.

Step 3 Now apply random strokes and splotches of vibrant contrasting color over your base paint layers. Use the same basic color palette for all three pages to create a cohesive set. Allow the paint to dry completely.

Step 4 Lay a sheet of tracing paper over each painted background and lightly sketch the outlines of each drawing to ensure the size and proportions are correct in relation to the background.

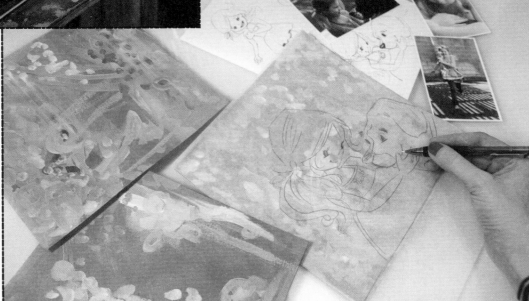

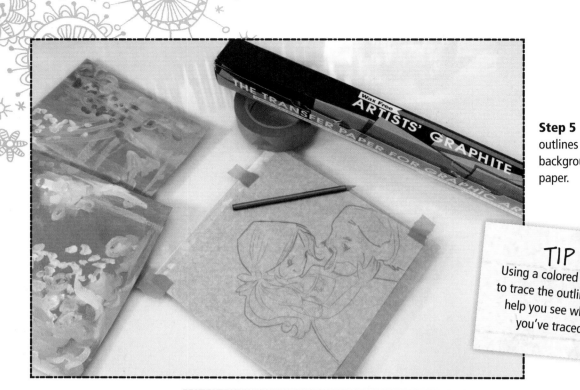

Step 5 Transfer your outlines onto each background using graphite paper.

TIP
Using a colored pencil to trace the outline will help you see where you've traced.

Step 6 Paint inside your outlined areas with white acrylic paint. It's okay if certain spots are not completely covered. Texture is good!

Step 7 Once the white paint dries, sketch or transfer your character on top. Trace over your lines with black marker.

Step 8 Paint each of the three pants hangers in a bright shade that matches your painted backgrounds. Then use a black art marker to embellish your plain white knobs.

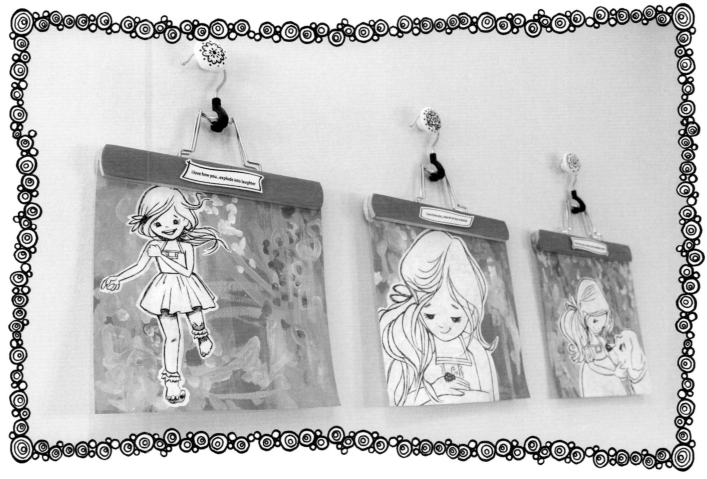

Step 9 Mount the knobs to a wall in a row. Clip each piece of art in a hanger and hang one on each knob for a charming display.

Illustrating Themes

Creating themed illustration sets is fun, especially when designing stationery, cake toppers, personalized scrapbooks, and the like. Follow the steps below to help move your creative ideas from inspiration to planned illustrations. Then use the spaces on the opposite page to come up with your own ideas.

Brainstorm Ideas

Colors (blue, purple, green)
Characters/People (Shakespeare, Einstein, Scrooge)
Animals (dog, cat, bird)
Banner and Border Designs (squiggles, flags, arches)
Natural Objects (seashells, palm trees, flowers)
Foods (cupcakes, cookies, pie)
Embellishments (beads, glitter, sequins)
Fabrics (satin, velvet, tweed)
Places (Paris, New York, London)

Step 1: Empty Your Brain Using these prompts as a guide, jot down (or doodle) every item you can think of that fits your theme. For example, if your theme is nautical, you might think of the colors blue and green; a sailboat; an old fisherman; and miscellaneous objects such as an anchor, rope, and a fishing net.

Illustration Project Ideas

Party Printables
Invitations
Food Labels
Cake Topper
Straw Flags
Banners
Goodie Bags

Stationery
Blank Notecards
Envelope Stickers
Return Address Labels

Apparel
Coordinating Patterns &
Screenprint Graphics

Scrapbooking Sets
Frames/borders
Word Bubbles
Corners
Cutout Shapes
Headers/banners
Patterned Papers
Stickers
Arrows

Wedding Sets
Monograms
Embroidery Motifs
Silhouetted Icons
Favor & Napkin Art
Quotables
Calligraphed Date

Step 2: List Project Ideas Next, using your brainstorming session as a guide, group your best project ideas into categories.

Source Suggestions

Books
Fashion and Decorating Magazines
Internet
Personal and Family Photos
Paint Chips
Fabric Swatches
Nature
Shopping Trips
Your Imagination!

Step 3: Source Images Based on your lists, search for source materials. You can always use your own imagination, but if you get stuck, you can find inspiration almost everywhere.

Brainstorm Ideas

1.
2.
3.
4.
5.
6.
7.
8.
9.
10.
11.
12.
13.
14.
15.
16.
17.
18.
19.
20.

Illustration Project Ideas

1.
2.
3.
4.
5.
6.
7.
8.
9.
10.
11.
12.
13.
14.
15.
16.
17.
18.
19.
20.

Creating a Style Board

Style boards, sometimes called mood boards, are great for collecting inspirational visual references. Although some artists create style boards on an actual corkboard, others simply use a sketch pad or notebook. Some artists illustrate their own style boards to work out their themes and project ideas.

This sample illustrated style board is a western theme, complete with a bandana, burlap, and denim!

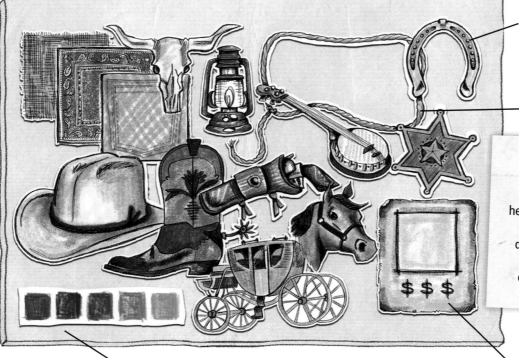

Horseshoes are a lucky charm

Lassos make a great frame or word bubble

TIP
Style boards are especially helpful if your goal is to design housewares, textiles, party décor, greeting cards, or any type of holiday or special occasion-themed artwork!

Wanted posters are great for photo frames in a scrapbook or photo invitations

Color swatches in a neutral "Americana" scheme

Styleboarding 101

There is no right way or wrong way to create a style board. They consist of everything from personal doodles and photographs to ribbons and buttons. Other style board elements include:

• Color palettes. Scribble color selections using colored pencils or attach paint chips.
• Photos. Make copies from library books, snap photos when inspiration strikes, and clip images from magazines.
• Three-Dimensional items related to your theme such as seashells, costume jewelry, chopsticks, or pressed flowers.
• Fabric swatches and patterned papers.
• Sentimental items such as letters, cards, or sketches.
• Anything else that sparks your creativity!

Follow the steps below to create your own
illustrated themed style board on pages 114-115.

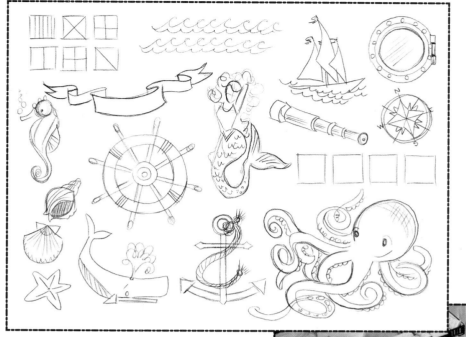

Step 1 Using your source images as a reference, loosely sketch your favorite items. Focus on each subject's main characteristics. Consider proportion, scale, shape, patterns, and dominant colors, but leave room to add your own artistic interpretation later.

Step 2 Add color using paint, markers, colored pencils, or crayons.

TIP
You can use your style board for inspiration, or cut out the finished pieces and use them in your project, as I did in my "Vacation Scrapbook" on page 116.

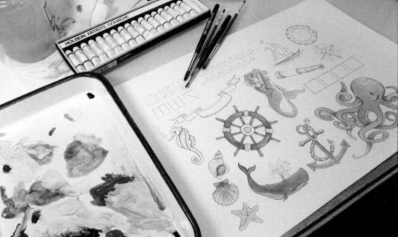

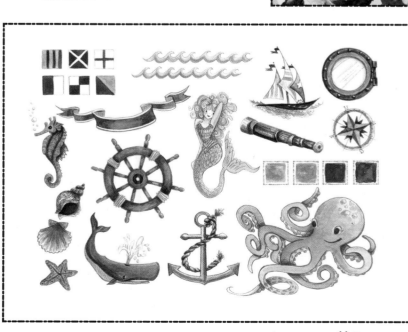

Step 3 Tailor your style board to its selected theme. For example, if your theme is a baby shower, use a muted color palette and delicate outlines. If your theme is a rock concert, use strong colors and a graphic style. This nautical set is tied together through a muted color scheme, watercolor texture, and whimsical illustration style.

Practice Here!

115

Vacation Scrapbook

This project demonstrates a fun way to bring a set of themed illustrations to life. You don't need to use every element in your themed illustration set; rather choose the pieces that fit your photos. Resize your illustrations as needed, repeating borders, frames, and similar motifs for consistency.

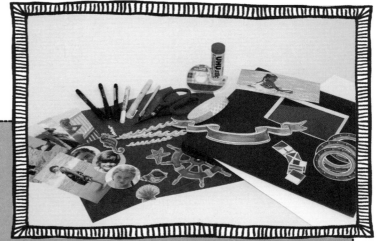

Tools & Materials

- Scrapbook
- Vacation photos
- Themed illustrations
- Assorted colored papers and scrapbooking elements
- Scissors or craft knife
- Paper punches
- Foam tape
- Double-sided tape
- Acid-free glue stick
- Markers, gel pens, or paint pens
- Computer, scanner, and printer (if needed to size illustrations)

Step 1 Sketch a layout on plain paper based on your scrapbook size. This will be your planning blueprint. Print and trim your illustrations and photos according to your sketch so everything will fit nicely.

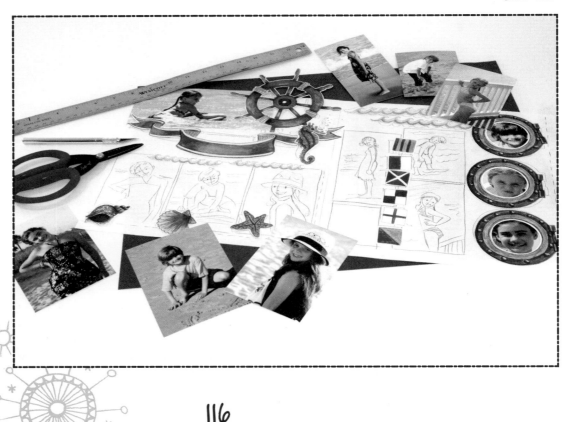

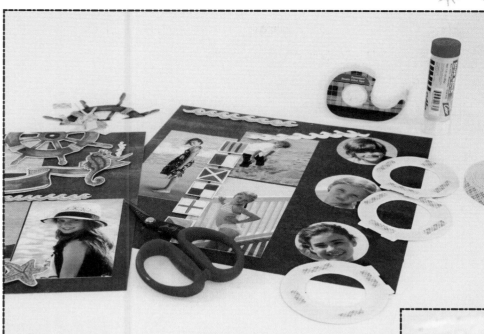

Step 2 Use glue and tape to adhere the elements to the pages of the scrapbook. Try using foam tape to add dimension and height! (See inset.)

TIP
Add finishing touches with a paint pen or gel pen to personalize the page. You may want to include dates, places, and names of the people in your photos to help tell the story!

Step 3 Add a few hand-drawn details and labels to tie the theme together.

BEACH

SUM MER 2012

Vintage Illustration

Adding vintage illustration techniques to your repertoire is a fun practice that can also improve and stretch your artistic muscles. Vintage illustration has certain defining characteristics. Below are a few techniques that give drawings an old-world feel.

Hatching Draw groups of thin parallel lines. Lines drawn closer together suggest light shading.

TIP
Take your time with this kind of art. With the technological aid of digital cameras, scanners, and software, it's easy to forget the patience and care that was once taken to create intricate illustrations without an "undo" button.

Cross-hatching Layer one set of hatched lines across another set going in a different direction. The result is a crisscross effect that adds shade and texture.

Stippling Create a series of dots, either densely packed or sparsely spaced, to add darker or lighter shading, respectively.

Directional lines Draw a series of lines that follow the contour of the object being shaded.

Flourishes and ornaments Add decorative florals, swirls, swooshes, frames, and corners that are synonymous with vintage illustration.

Vintage-Inspired Art

Use a fine-tipped pen or mechanical pencil to create thin-stroked drawings and letters, following the techniques described on the opposite page. Use the images here as inspiration to get started.

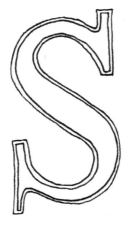

Step 1 Draw the outline of a letter in a vintage-inspired serif type.

Step 2 Fill in the outline to create a monogram.

Step 3 Add flourishes and embellishments around the letter to create an ornate border.

Sepia-toned Vignette

Choose a special family photo from which to illustrate and color a keepsake heirloom. Make sure to include a caption and signature in pencil, adding the date to give a sense of time and place.

Step 1 Using your reference photo as a guide, lightly sketch your drawing with pencil. When you are finished, erase unneeded sketch lines and trace over the drawing with a fine-tipped black ink pen.

TIP
Drawing on watercolor paper is great for adding texture to your artwork.

Step 2 Dilute sepia-colored india ink with water and apply faint shading to your drawing. Stop here if you want to preserve an extra old-fashioned feel. To add more color, move on to step 3.

120

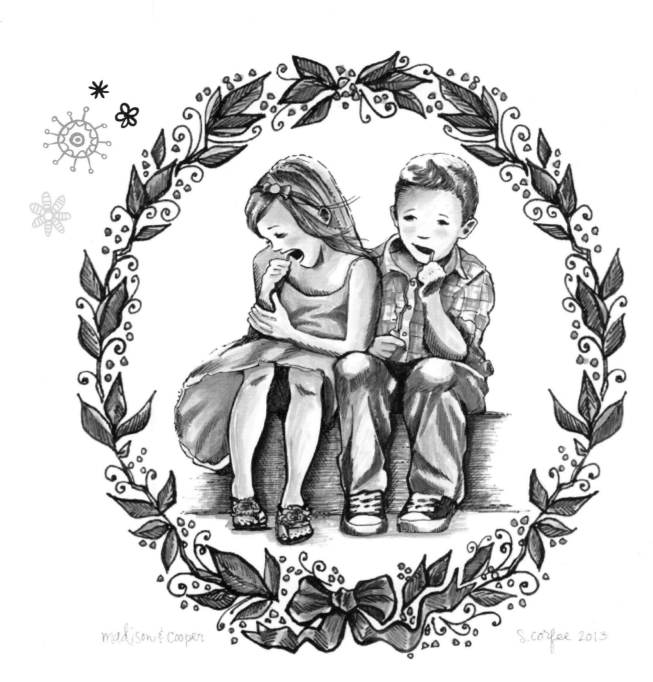

madison & cooper

S. coffee 2013

Step 3 Establish a limited color palette. Using loose strokes with light pressure, add soft layers of watercolor for depth and tone.

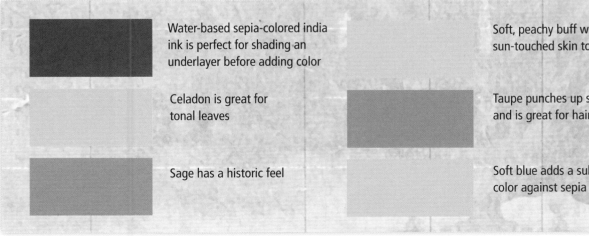

Water-based sepia-colored india ink is perfect for shading an underlayer before adding color

Celadon is great for tonal leaves

Sage has a historic feel

Soft, peachy buff works for sun-touched skin tones

Taupe punches up shadows and is great for hair

Soft blue adds a subtle pop of color against sepia tones

Practice Here!

Vintage-style Bookplates

With beautiful bindings and yellowed pages, old books have true vintage charm. Discover how to create classic illustrated bookplates that unify any book collection.

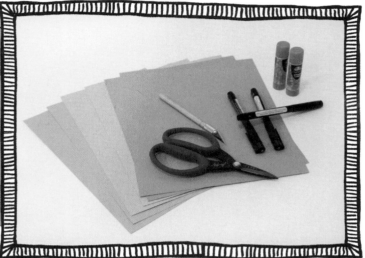

Tools & Materials
- Assorted textured art papers
- Fine-tip pens
- Scissors or craft knife
- Acid-free glue sticks
- Computer, scanner, and printer

Step 1 Decide on a theme for your bookplate set. Draw the motifs using vintage drawing techniques.

Step 2 Scan your illustrations.

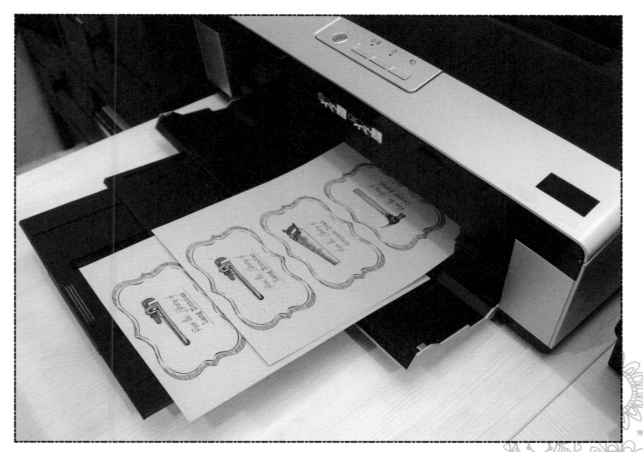

Step 3 Create a label using image-design software. Use vintage-inspired fonts and classic borders. Print your bookplates on textured or colored papers.

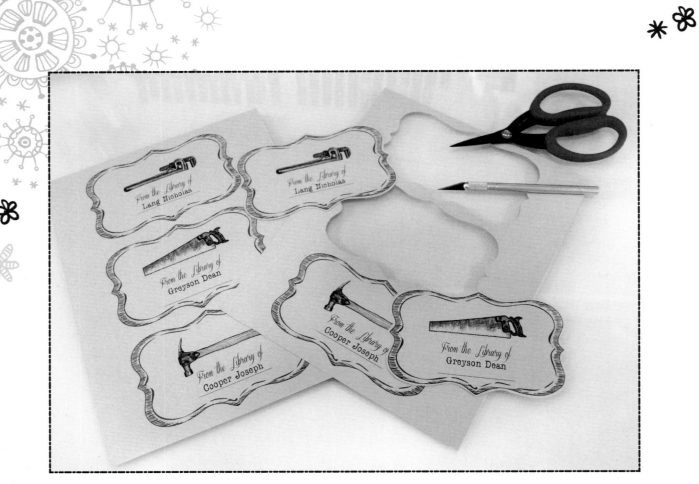

Step 4 Use scissors or a craft knife to trim the bookplates.

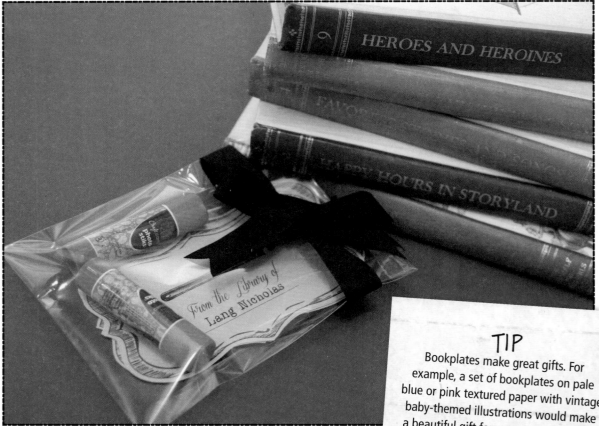

Step 5 Wrap up a set to be gifted. Be sure to include a couple acid-free glue sticks in the package.

TIP
Bookplates make great gifts. For example, a set of bookplates on pale blue or pink textured paper with vintage baby-themed illustrations would make a beautiful gift for new parents as they build their child's storybook library.

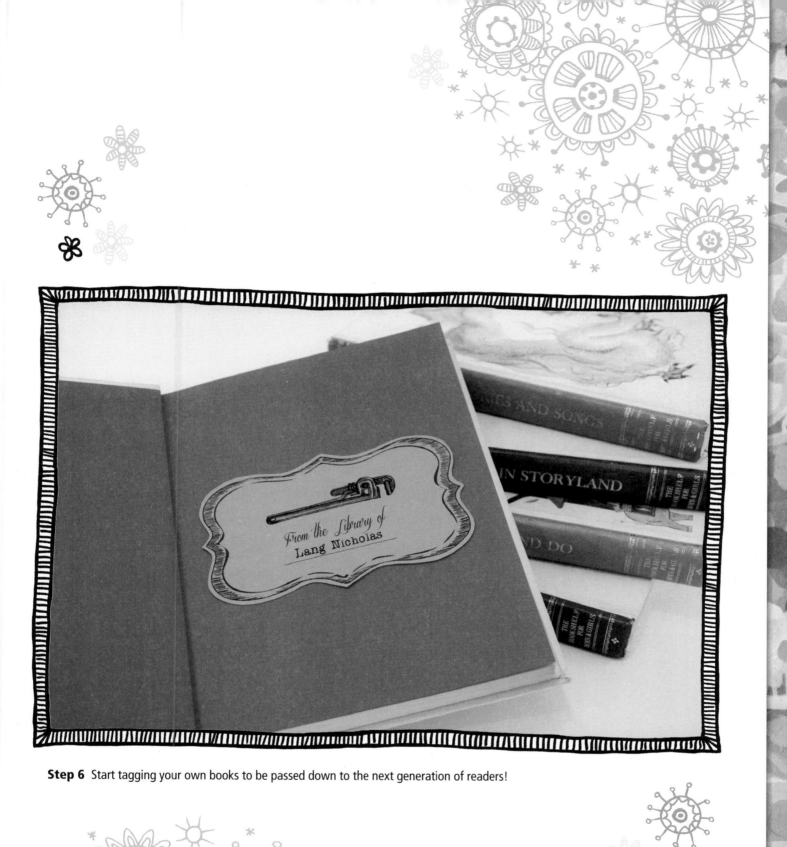

Step 6 Start tagging your own books to be passed down to the next generation of readers!

Retro-style Graphics

Retro-style graphics inspired by advertising of the 1940s and 1950s are popular in illustration design today for their timeless simplicity.

Strong Simple Graphics

Grab a handful of everyday items from around the house. Draw each one using just one color. Edit details carefully so the item remains recognizable. A simple silhouette is the easiest choice, but be sure not to overlook each object's defining characteristics.

One-Color Logos

Starting with a silhouette or line drawing, think about the defining characteristic of your subject. In the examples below, it is easy to infer that the dog is loud, the parrot is a talker, and the bunny is lovable. Challenge yourself to communicate details like this through simple graphics. Sketch in pencil to map out black-and-white spaces until you have a strong balance.

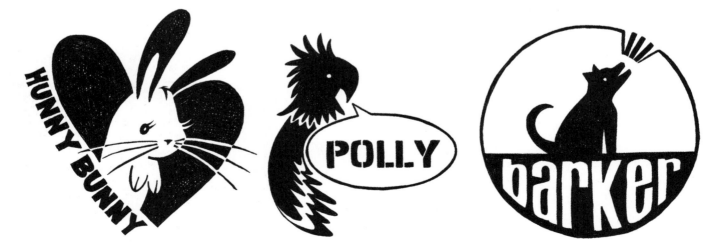

Retro Advertising

Mid-20th-century advertisements, logos, and branding capitalized on simple layout, bold typefaces, and limited color palettes. Visual "clutter" was not welcome. Many of the graphics and logos from this period are still used today. Logos were typically limited to one or two colors with minimal detail and a silhouetted or stamped look. Today these elements are the hallmarks of retro style, especially vintage advertising graphics. Use the art below to inspire your own retro-themed illustrations.

Retro Motifs

There are certain recurring elements that characterize a retro style of illustration. The following exercises demonstrate how to create some of the most classic and popular motifs.

Wave Banner

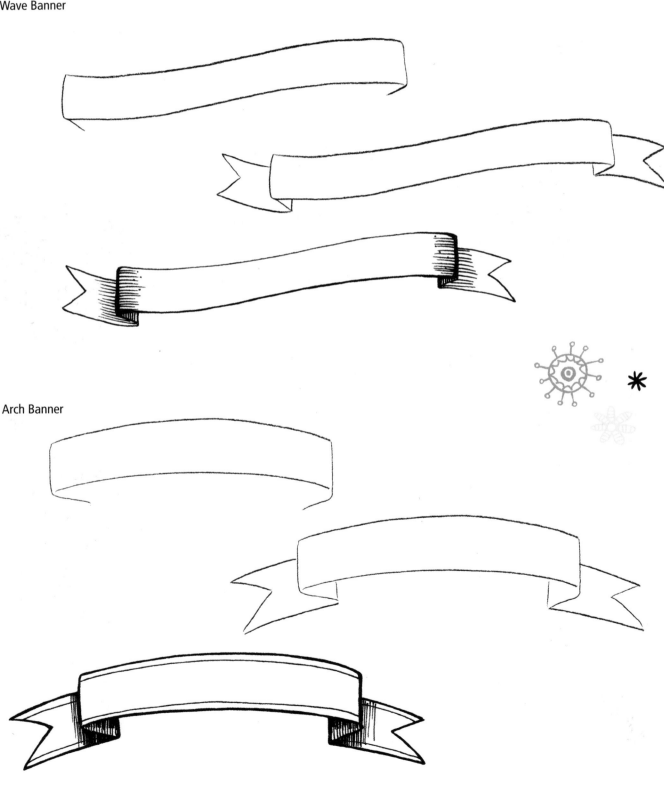

Arch Banner

Crest

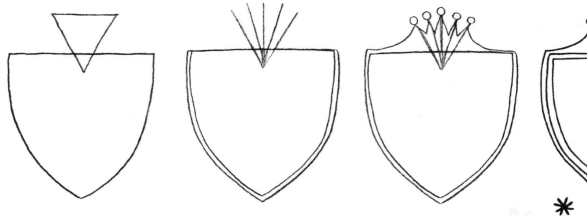
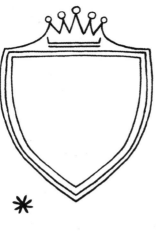

Medallion

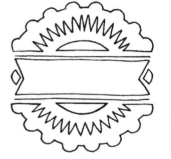
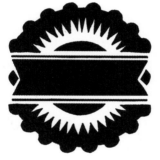

Sunburst

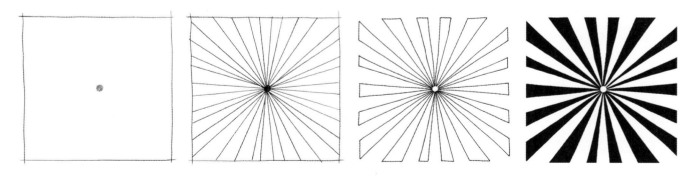

Starbursts

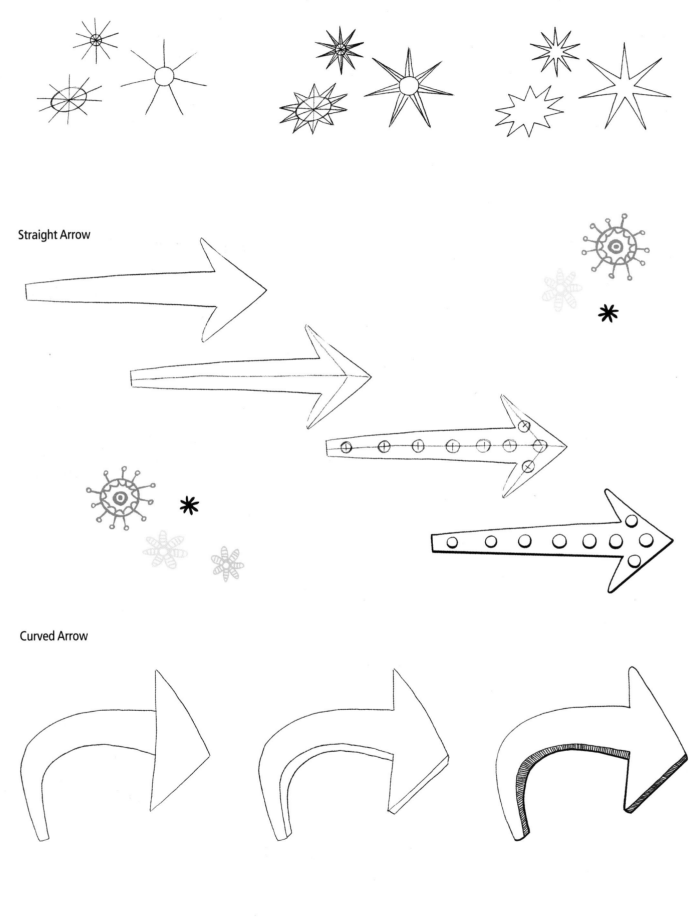

Straight Arrow

Curved Arrow

Angled Text

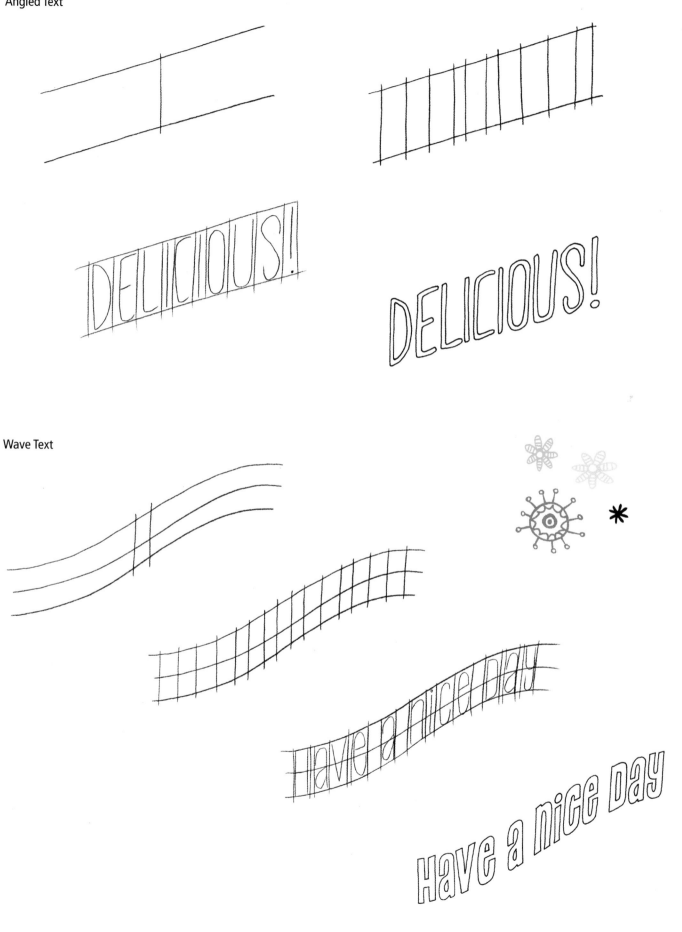

DELICIOUS!

DELICIOUS!

Wave Text

Have a nice Day

Have a nice Day

Practice Here!

Swingin' Style

Using the artwork below as inspiration, try your hand at illustrating in a swingin' retro style on the opposite page.

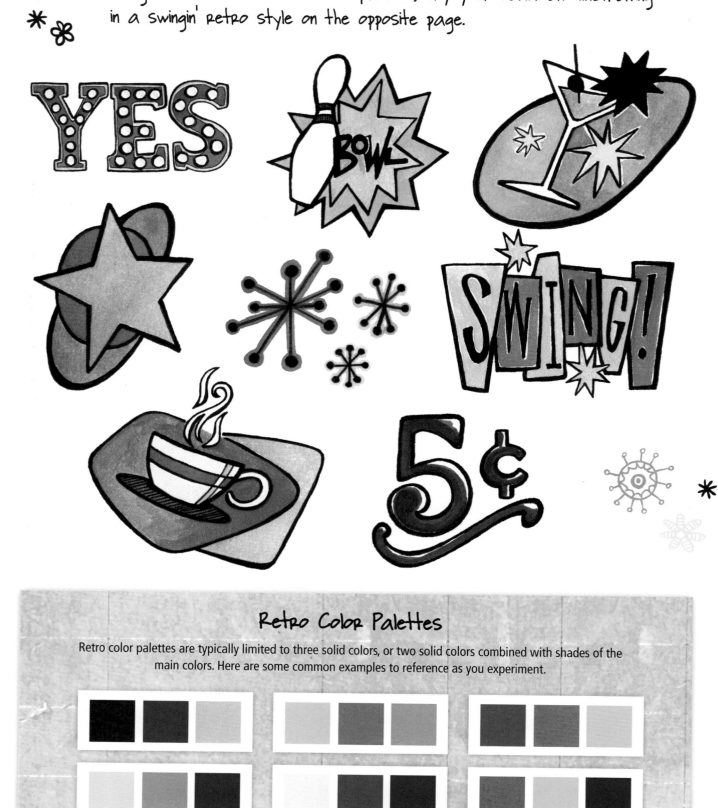

Retro Color Palettes

Retro color palettes are typically limited to three solid colors, or two solid colors combined with shades of the main colors. Here are some common examples to reference as you experiment.

Practice Here!

Nostalgia Sign

Retro signs have a lot of personality! The main graphic you choose will set the stage for the entire piece. Try a vintage child's toy for a playroom sign or a chic fashion icon for a friend's new apartment. The silhouette of a vintage car would be great for a den or man cave.

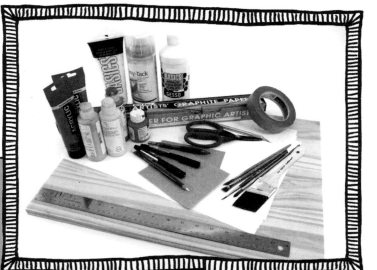

Tools & Materials

- Drawing pencil
- Wood board
- Acrylic paint in 2 complementary shades
- Primer/gesso
- Paintbrushes
- Painter's tape (optional)
- Fine grit sandpaper
- Straight edge

- Scissors or craft knife
- White watercolor pencil
- Copy paper
- Low-tack spray adhesive
- Graphite transfer paper
- Hanging hardware

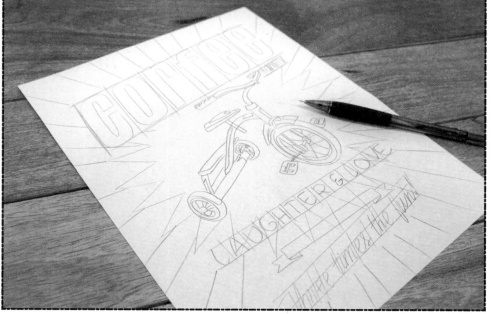

Step 1 Make a sketch of your ad-inspired layout using several classic retro motifs infused with your own personality and name.

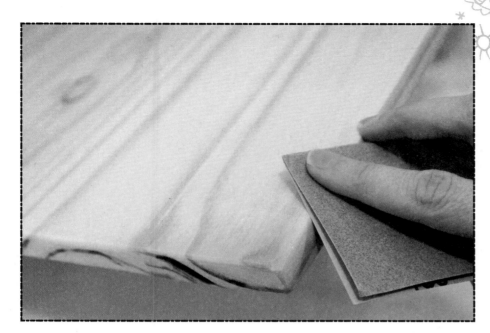

Step 2 Sand your wood board to take off any sharp corners or edges.

Step 3 Prime the board with household primer or gesso, and paint it the darker of your two background colors.

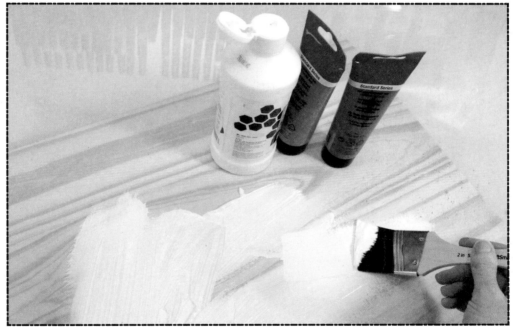

Step 4 When your base color is dry, use a straight edge and the watercolor pencil to draw in the sunburst lines. Mark every other space of the sunburst with an "x." These will be painted a lighter shade.

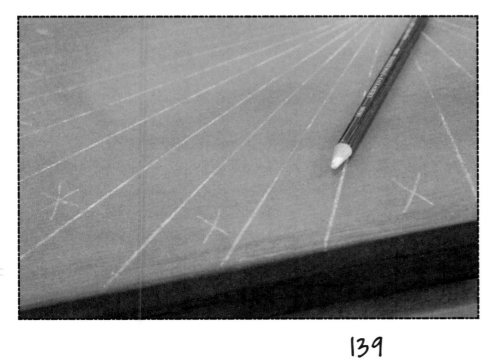

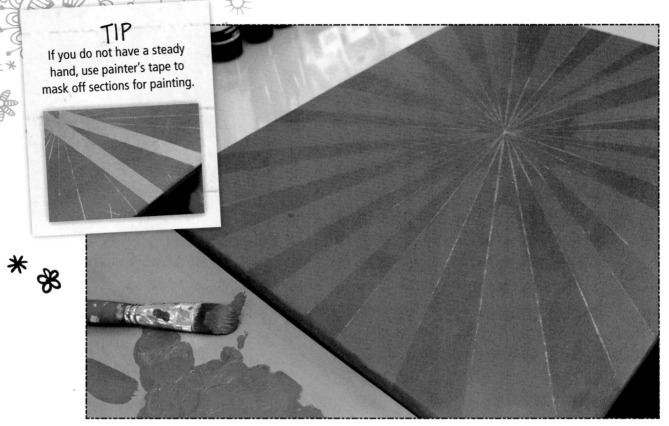

TIP
If you do not have a steady
hand, use painter's tape to
mask off sections for painting.

Step 5 Mix a little white with the background color to create a slightly lighter shade. Paint the "x" sections of the sunburst and let dry. Don't worry about painting all the way into the center. The sunburst graphic will cover much of the center area.

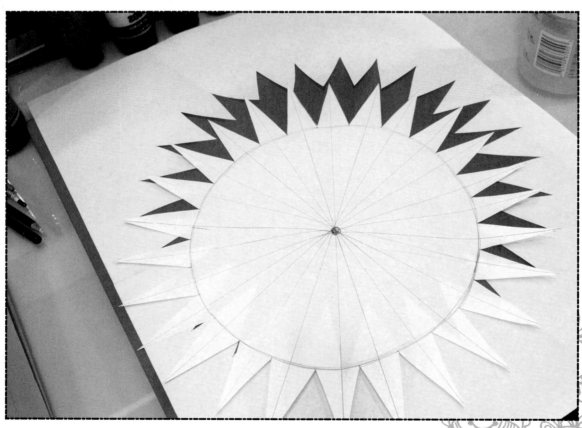

Step 6 Draw a sunburst (or other desired shape) on the copy paper; then cut it out to create a stencil. Spray the stencil with low-tack adhesive and apply to the board.

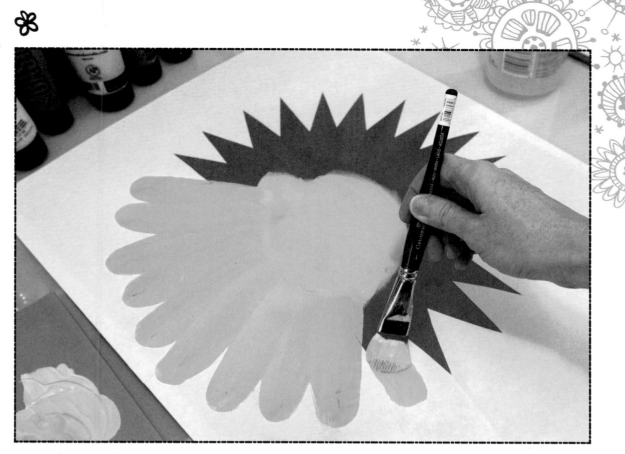

Step 7 Paint over the sunburst stencil with your second color. Apply brush strokes away from the template edges to avoid bleed.

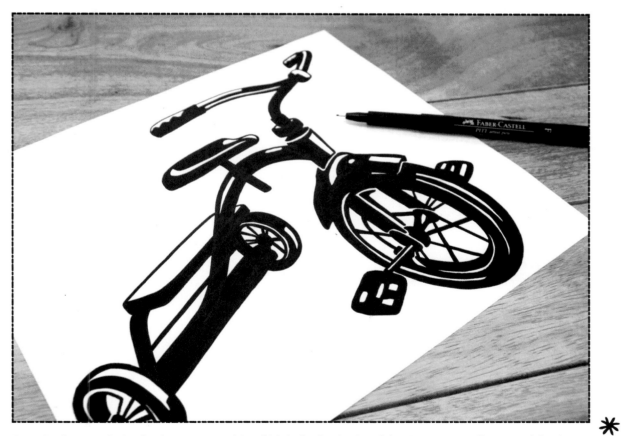

Step 8 Choose a design for the center graphic, which is the focal point of the sign. Draw a silhouette of the design at the desired size.

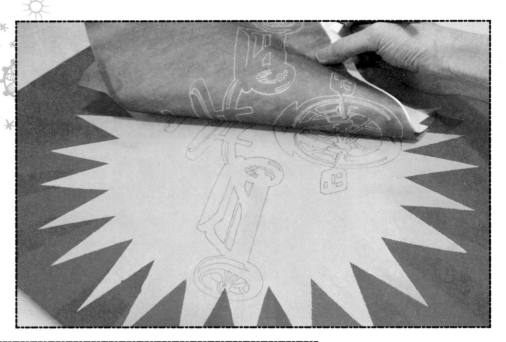

Step 9 Transfer the graphic design to the board using graphite transfer paper. Then paint your center graphic.

Step 10 Sketch your text onto the board. If you prefer to create your lettering on a separate page first, use graphite transfer paper to transfer it to the board. Paint your text.

Step 11 Use fine sandpaper or an electric hand sander to distress the painted art. Focus on the edges and corners of the board. Then lightly scuff some areas in the center.

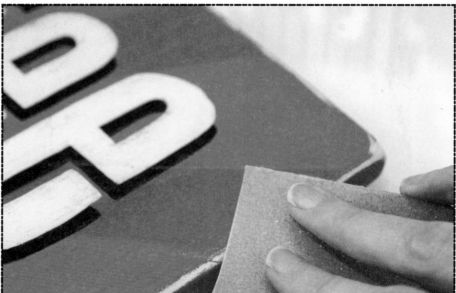

Step 12 Add hanging hardware and adhesive rubber pads to the back of the board to protect your wall.

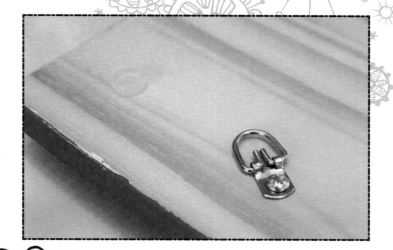

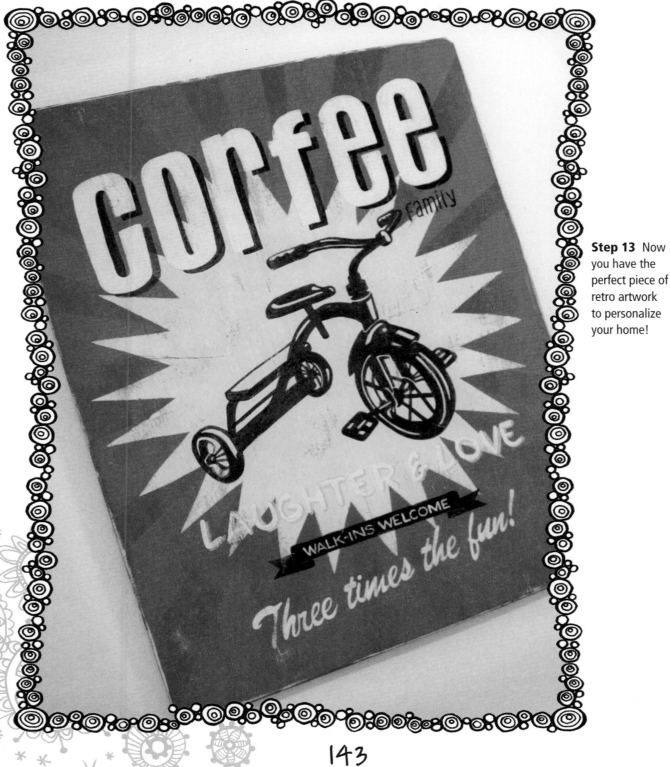

Step 13 Now you have the perfect piece of retro artwork to personalize your home!

About the Author

Stephanie Corfee is a full-time freelance artist
and designer living in Malvern, Pennsylvania.
She has worked in advertising and marketing
and previously owned her own wedding gown
design studio. Today Stephanie enjoys the creative
freedom that comes from owning her own business
while doing what she loves. She has a colorful,
bohemian personal aesthetic and loves creating
fun, whimsical art for children.
Visit www.stephaniecorfee.com.